For and because of Tony;
Infinity and forever Clyde and Louis.

© Damiani 2010
© photographs, Laura L. Letinsky
© texts, Mark Strand, Laura L. Letinsky

Laura L. Letinsky
After All

Photographs by Laura L. Letinsky
Texts by Mark Strand, Laura L. Letinsky
Graphic Design by Gianni Grandi, Enrico Costanza and Jason Pickleman

DAMIANI

Damiani editore
via Zanardi, 376
40131 Bologna
t. +39 051 63 50 805
f. +39 051 63 47 188
info@damianieditore.it
www.damianieditore.com

Editorial coordination
Enrico Costanza

American Representative
Alice Rose George

Translations
Isabelle Mansuy
Adelaide Cioni

Printed in April, 2010
by Grafiche Damiani, Bologna

ISBN 978-88-6208-132-0

AFTER ALL

PHOTOGRAPHS BY

Laura L. Letinsky

WORDS BY

Mark Strand and Laura L. Letinsky

[DAMIANI]

FOREWORD

MARK STRAND

The title of this book suggests more than the minimalist character of Laura Letinsky's recent photographs, it proclaims their distance from earlier embodiments of still life. The rotting fruit, wilted flowers, tipped glasses, half-eaten meals that are present in such profusion in 17th Century Dutch painting have given way to paper plates, plastic cups, tin cans and bottle tops disposed on white surfaces in white rooms. Instead of images of overabundance, we are presented with the more modest remains of a snack or a drink or a child's birthday party. But Ms. Letinsky's photographs, especially early in her book, are less concerned with the symbolic implication of leftovers than they are with the evocative power of light. The transformation of edges and surfaces of table, wall, and room into shifting zones of off-whites and warm to cool grays creates interiors that are at once understated and luminous.

As the book progresses, the photographs become darker and the scattered objects more plentiful. Those accents of bright color used so sparingly near the beginning of the book give way to arrangements that seem less random and spaces that though less ethereal are no less mysterious. This literal darkening of the book's progress echoes, naturally, the passage of time, which only deepens whatever indications there are that pleasure was had and now has passed. In the starkest of these photographs a small, half eaten piece of cake — perhaps a birthday cake — sits on a napkin, surrounded by a deep and unrelenting dark, a touching sign that fulfillment or happiness has limits and is provisional. But what is not provisional is how consistently these photographs maintain their poise, how remarkably the accidental and the intentional, the casual and the formal, are balanced, and how their refinement, encompassing both the sparseness of the lighter still lifes and the ravishing gloom of the darker ones, transcends the melancholy news they bear.

Le titre de ce livre ne fait pas que suggérer le caractère minimaliste des photographies récentes de Laura Letinsky, il proclame leur éloignement des incarnations de la nature morte auparavant. Les fruits décomposés, les fleurs fanées, les verres renversés, les repas mangés à moitié qui sont présents à profusion dans la peinture hollandaise du 17è siècle ont ouvert la voie aux assiettes en papier, aux tasses en plastique, aux boîtes de conserve et aux bouchons de bouteille disposés sur des surfaces blanches dans des pièces blanches. Au lieu d'images de surabondance nous sont présentés de manière beaucoup plus modeste des restes d'un casse-croûte, d'une boisson ou d'un goûter d'anniversaire. Mais les photographies de Mme Letinsky, particulièrement au début de son livre, sont moins concernées par l'implication symbolique des restes que par la puissance évocatrice de la lumière. La transformation d'angles et de surfaces de table, de mur et de pièce en des zones mouvantes allant du chaud blanc cassé aux gris froids crée des intérieurs qui sont soudain minimisés et lumineux. Plus le livre progresse et plus les photographies deviennent sombres, et plus les objets dispersés sont abondants. Ces accents de couleur vive utilisés en si petite quantité au début du livre ouvrent la voie à des arrangements qui semblent moins aléatoires et à des espaces qui, bien que moins éthérés, n'en sont pas moins mystérieux. L'assombrissement littéral à mesure que le livre progresse fait, bien sûr, écho au passage du temps qui ne fait que fait qu'accentuer l'indication du plaisir qui a été obtenu et le fait qu'il est maintenant passé. Dans la plus forte de ces photographies, un petit morceau de gâteau — peut-être un gâteau d'anniversaire — à moitié mangé est posé sur une serviette, encerclé d'un noir profond et tenace, un signe touchant du fait que l'épanouissement ou le bonheur a des limites et est provisoire. Mais ce qui n'est pas provisoire, c'est la manière dont ces photographies gardent leur équilibre, à quel point sont remarquablement balancés l'accidentel et l'intentionnel, le casuel et le formel, et la façon dont leur raffinement, englobant à la fois l'éparpillement des natures mortes les plus légères et la ravissante obscurité des plus sombres, transcende la mélancolie qu'elles portent en elles.

Il titolo di questo libro allude a qualcosa di più che al carattere minimalista delle ultime fotografie di Laura Letinsky, proclama il loro distanziarsi da esempi precedenti di nature morte. La frutta marcia, i fiori appassiti, i bicchieri rovesciati, i pasti mezzi consumati, tanto presenti nella pittura fiamminga del Seicento, hanno lasciato il posto a piatti di carta, bicchieri di plastica, lattine e tappi di bottiglie disposti su superfici bianche dentro stanze bianche. Invece di immagini di sovrabbondanza, qui ci troviamo di fronte ai resti ben più modesti di una merenda, di un aperitivo o della festa di compleanno di un bambino. Ma più che sui sottintesi simbolici dei resti, le fotografie di Letinsky, specie nella prima parte del libro, si concentrano sul potere evocativo della luce: i bordi e le superfici di tavoli, muri e stanze si trasformano in aree cangianti di bianchi sporchi e grigi da caldi a freddi, e creano interni al tempo stesso sobri e luminosi.

Con il procedere del libro le fotografie si scuriscono e gli oggetti aumentano. Certi accenti di colore acceso, usati in modo così parco nelle prime pagine, cedono il passo a disposizioni che sembrano meno casuali e a spazi che pur se meno eterei mantengono un'aura di mistero. Naturalmente questo letterale scurimento da una pagina all'altra del libro riecheggia il passare del tempo e dà spessore a quegli indizi che tradiscono un piacere provato e ormai finito. Nella più cruda delle fotografie un pezzetto di torta mezzo mangiato — forse una torta di compleanno — è appoggiato su un fazzoletto, assediato da un buio fondo e inesorabile, segno toccante che l'appagamento o la felicità hanno dei limiti, sono provvisori. Ma non è provvisoria la costanza con cui queste fotografie mantengono la loro compostezza, il loro straordinario equilibrio fra il fortuito e il voluto, lo spontaneo e il formale, né è provvisoria la loro capacità di trascendere per mezzo di una raffinatezza che permea tanto la rarefazione delle nature morte più luminose quanto l'incantevole cupezza delle più scure il messaggio malinconico che portano in sé.

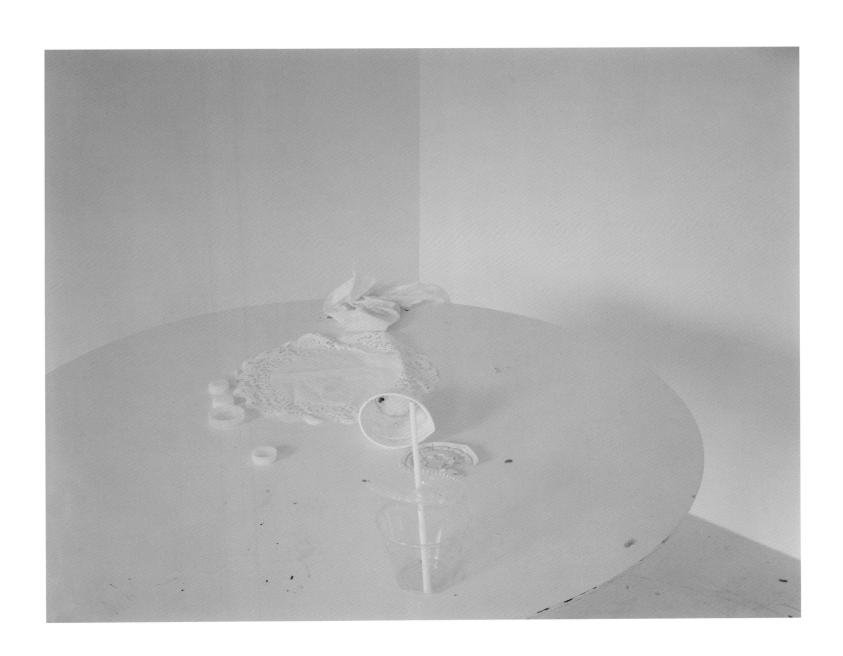

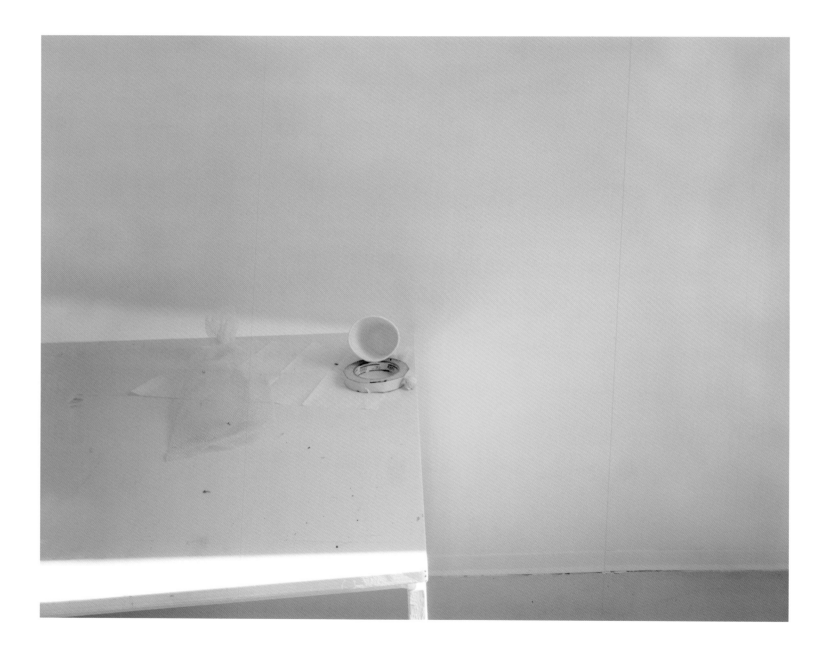

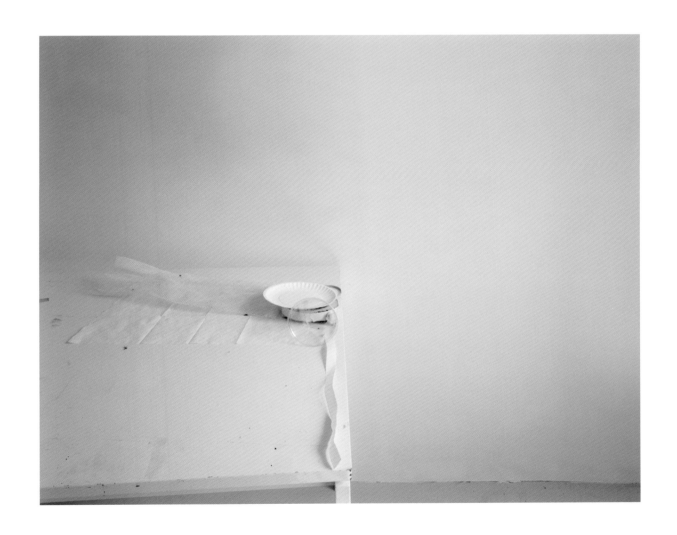

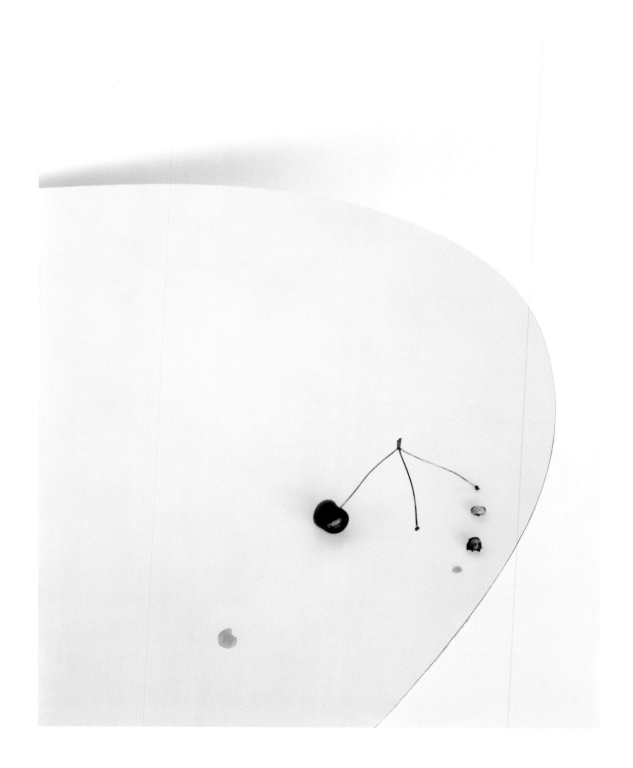

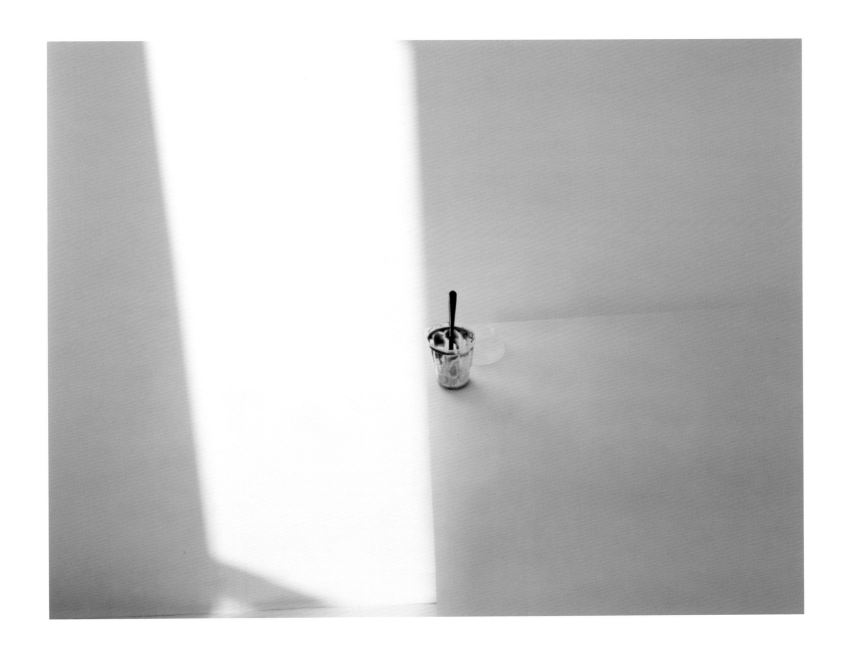

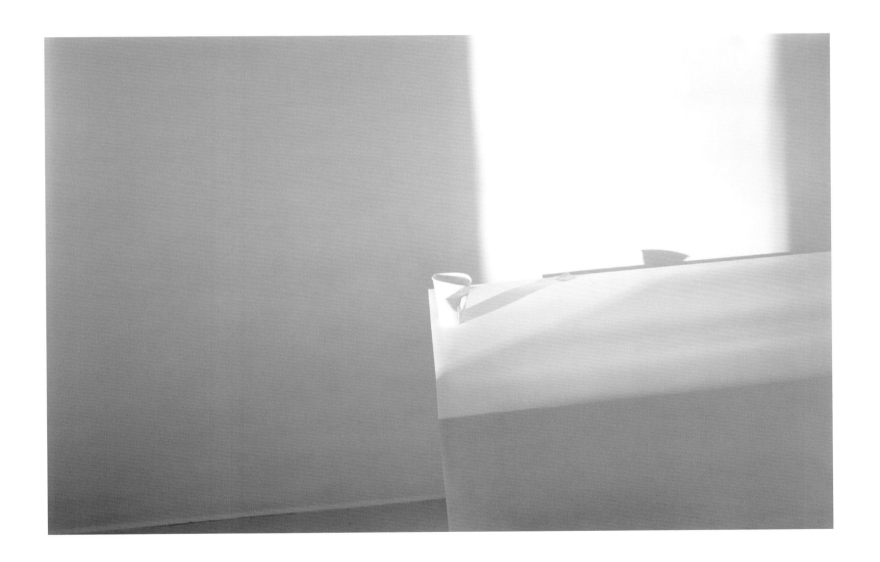

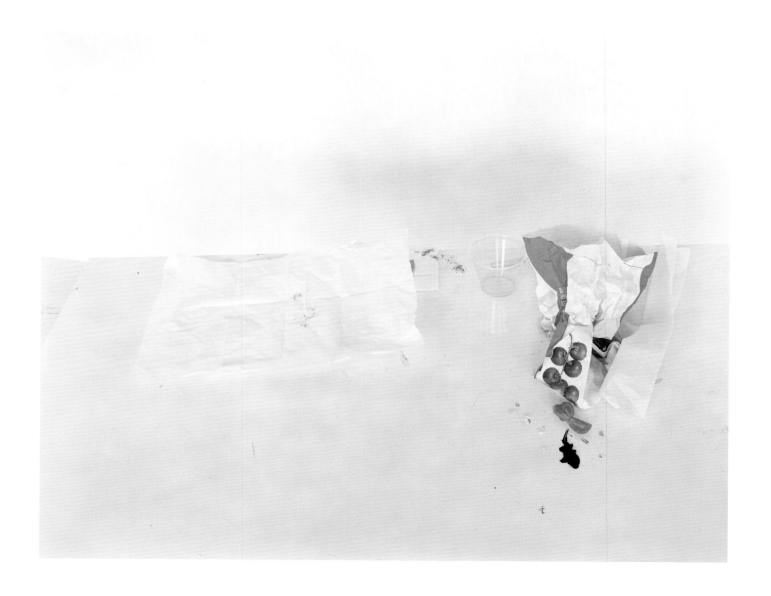

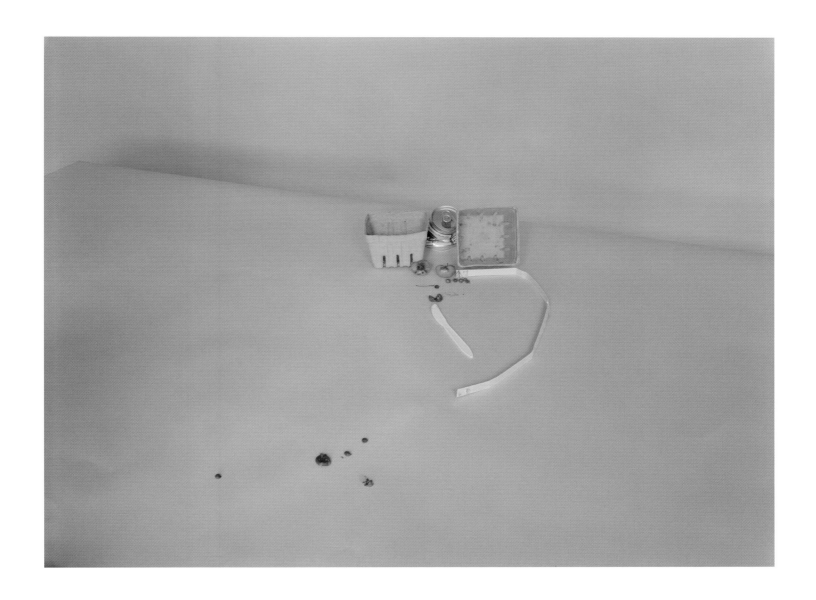

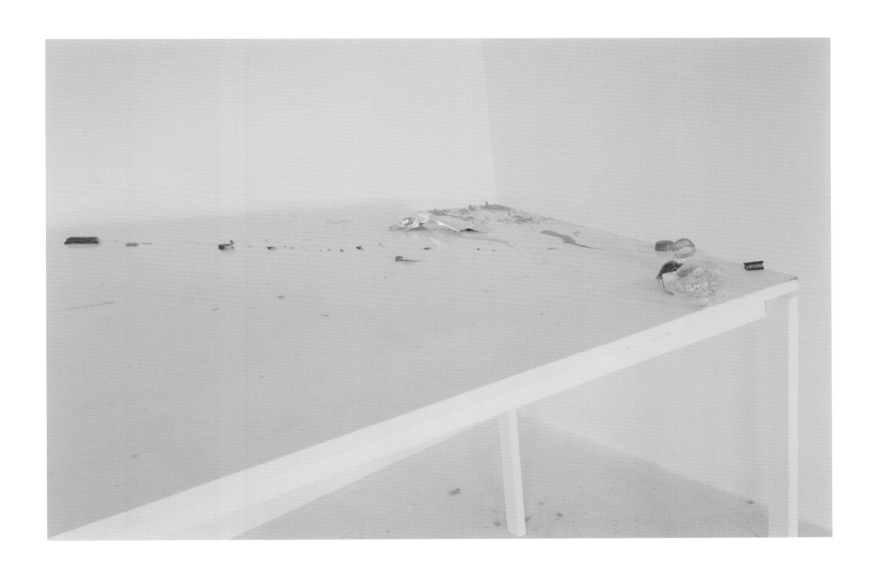

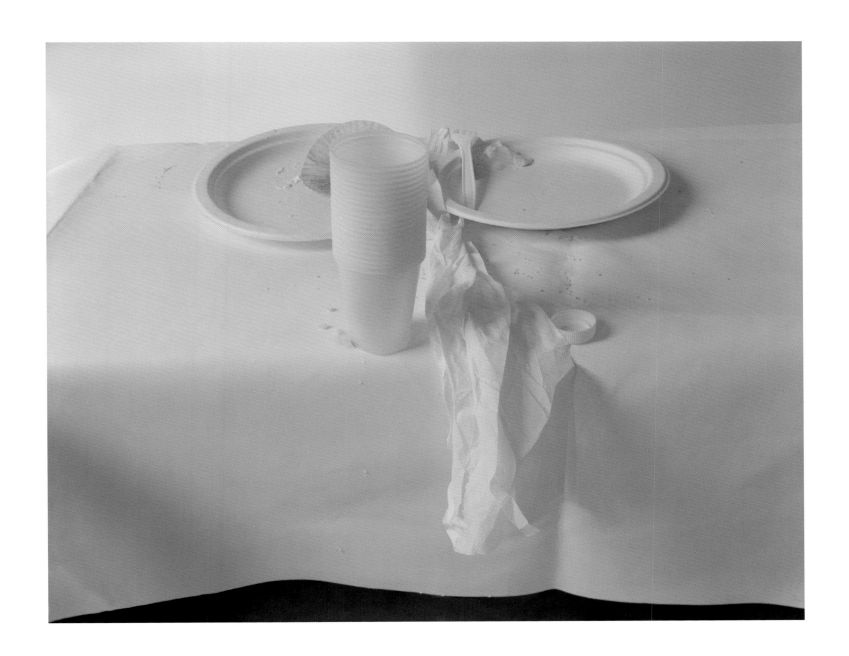

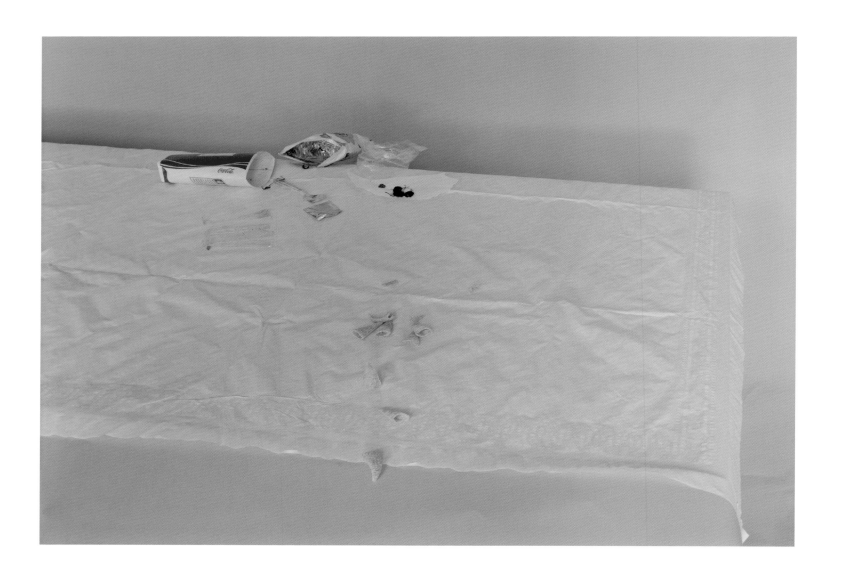

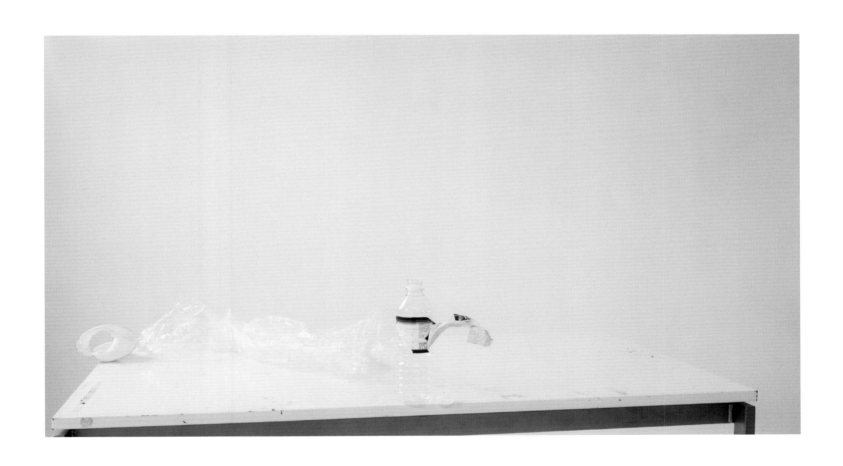

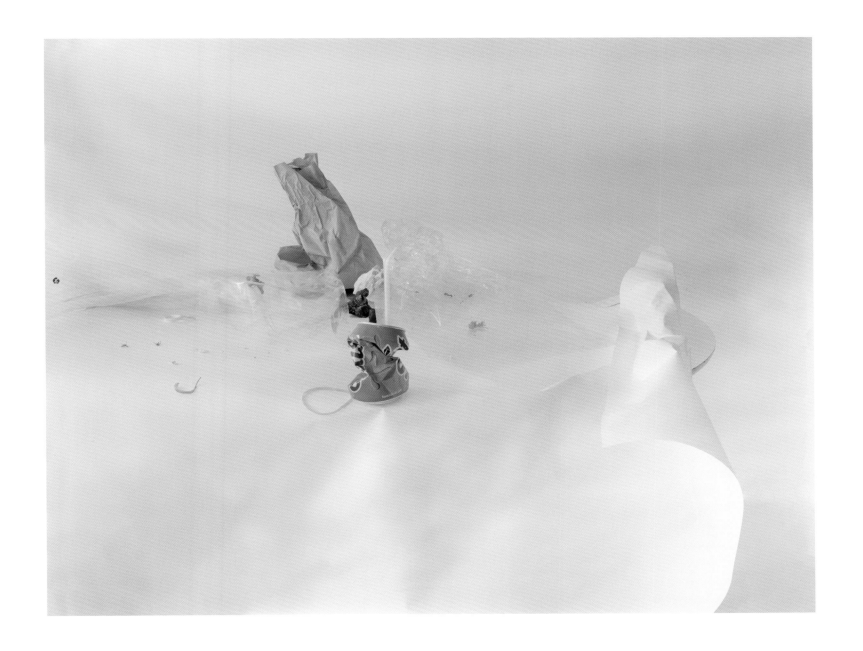

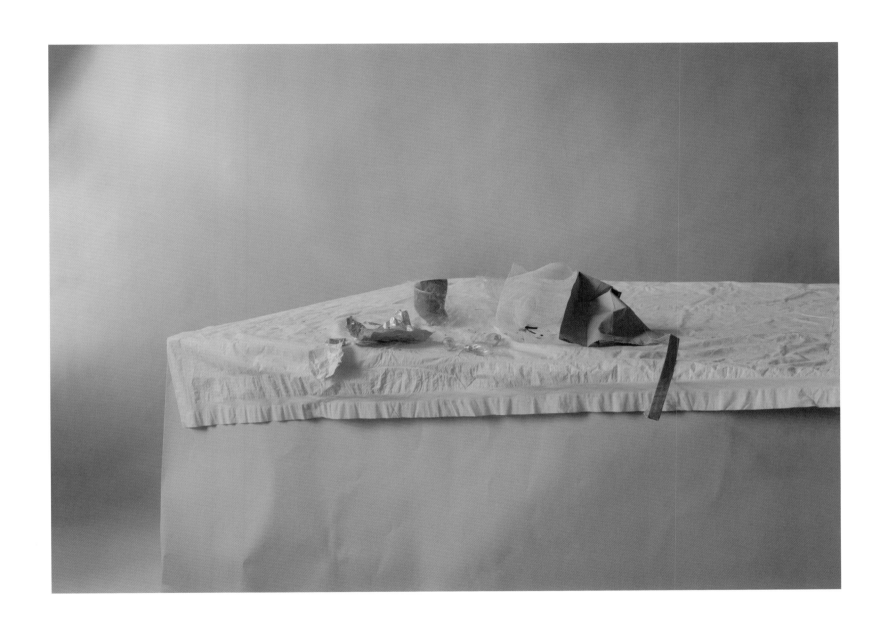

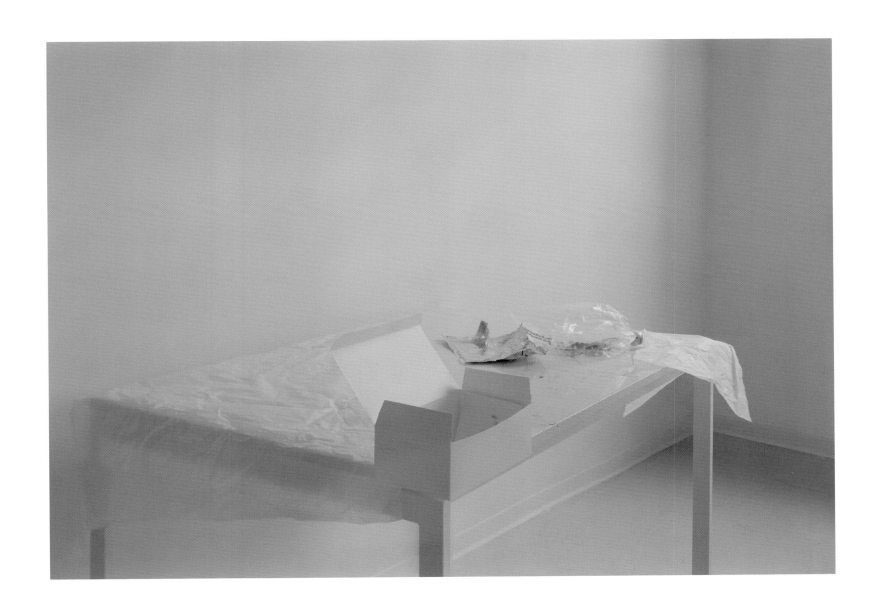

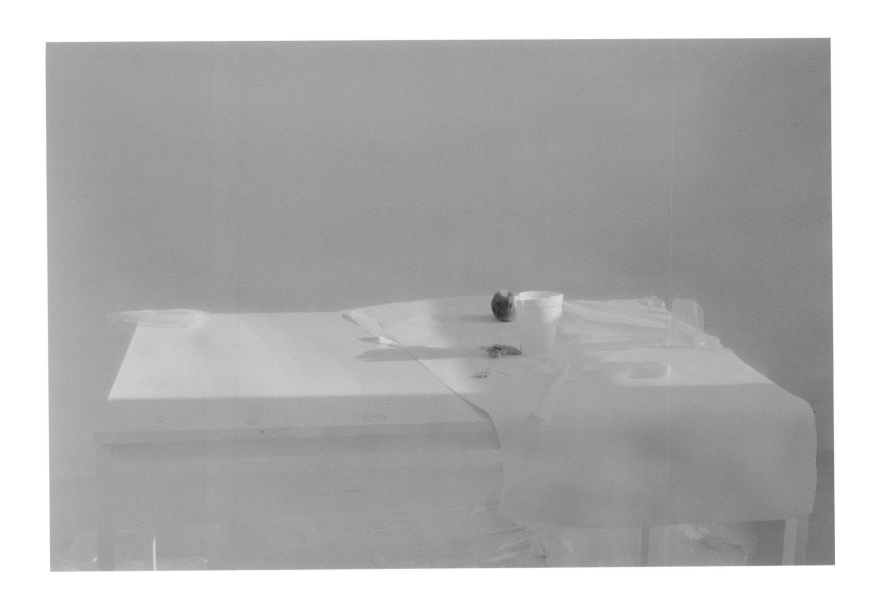

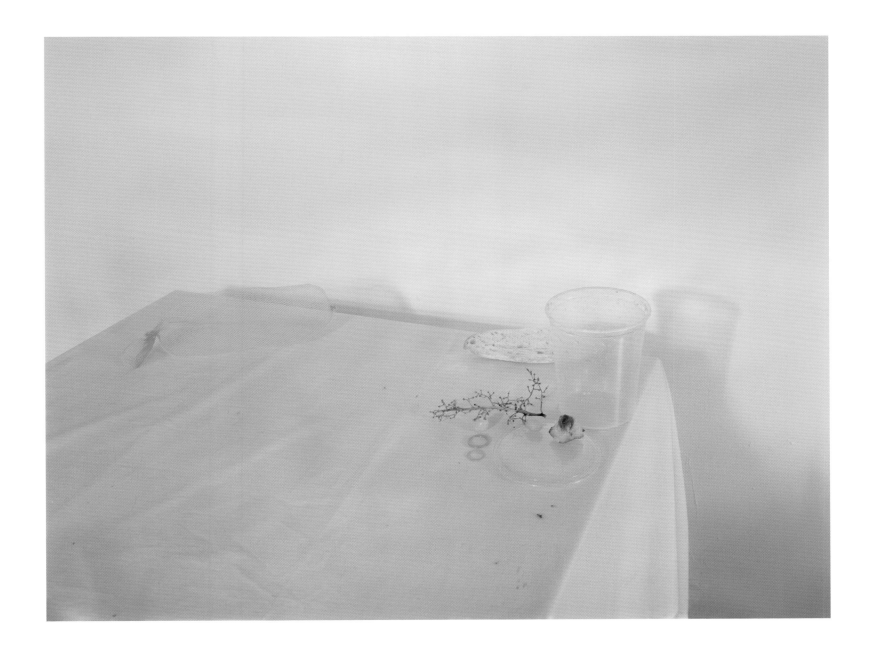

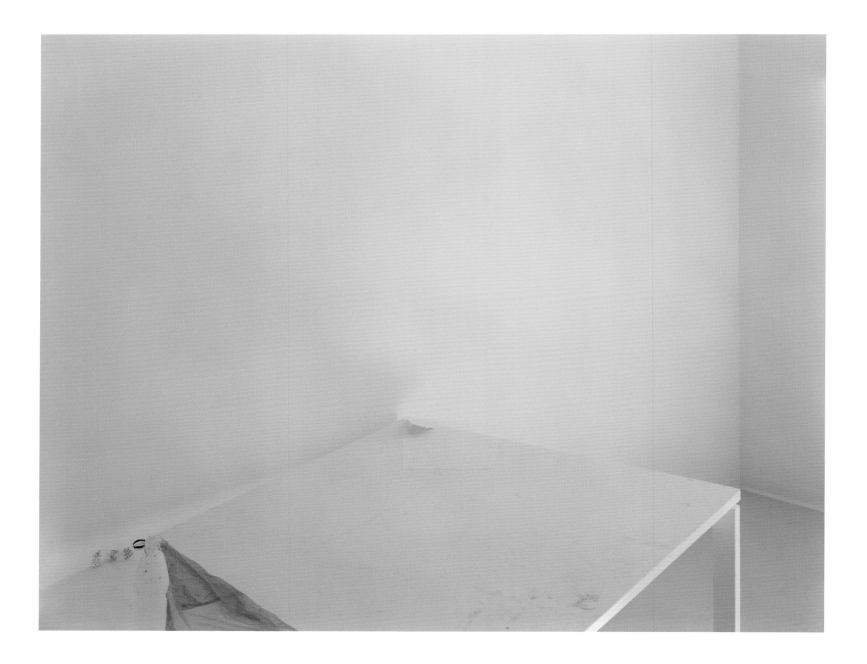

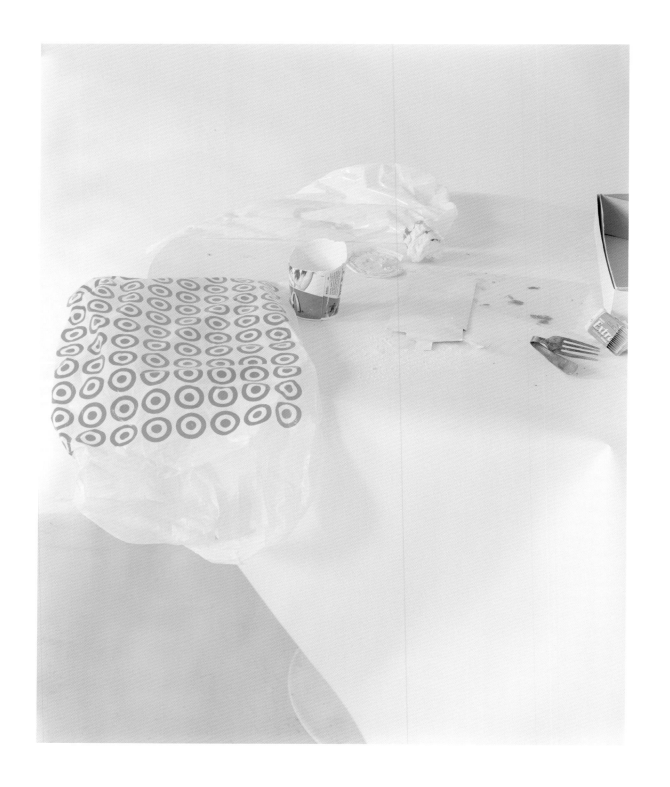

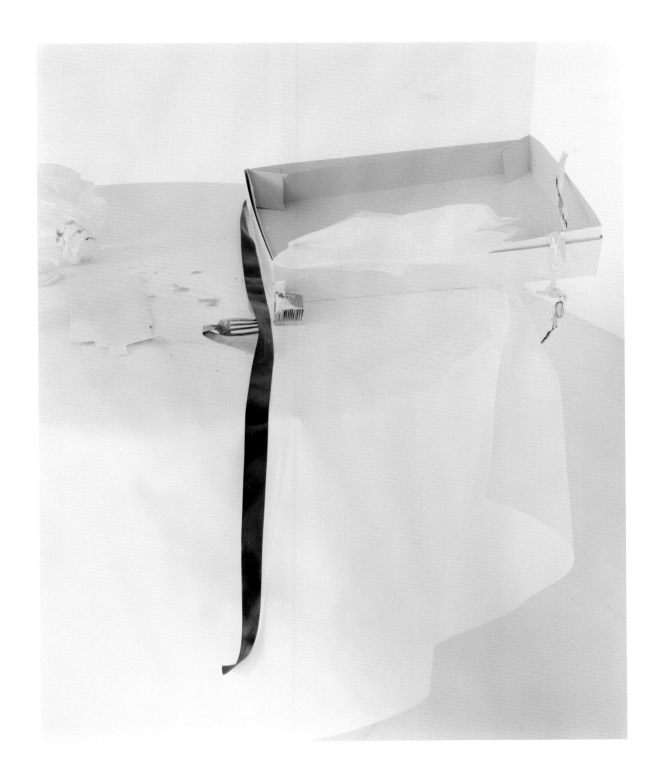

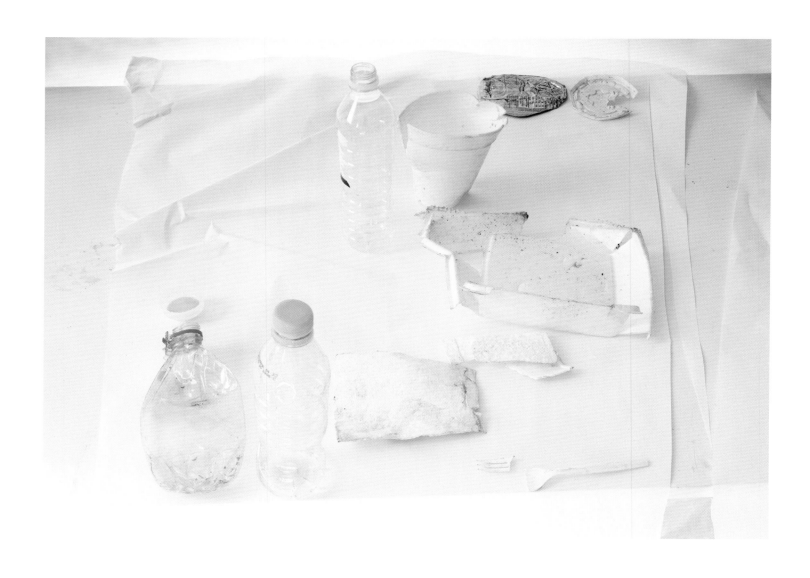

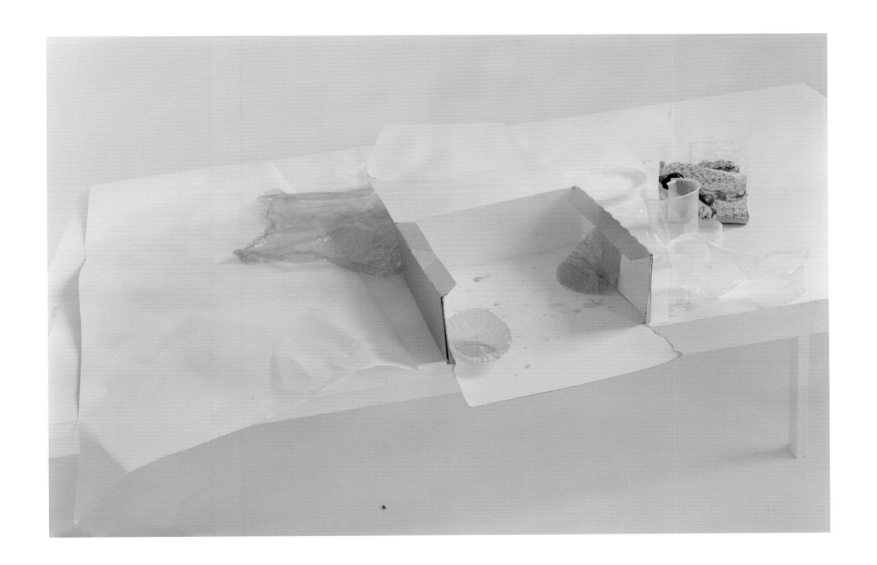

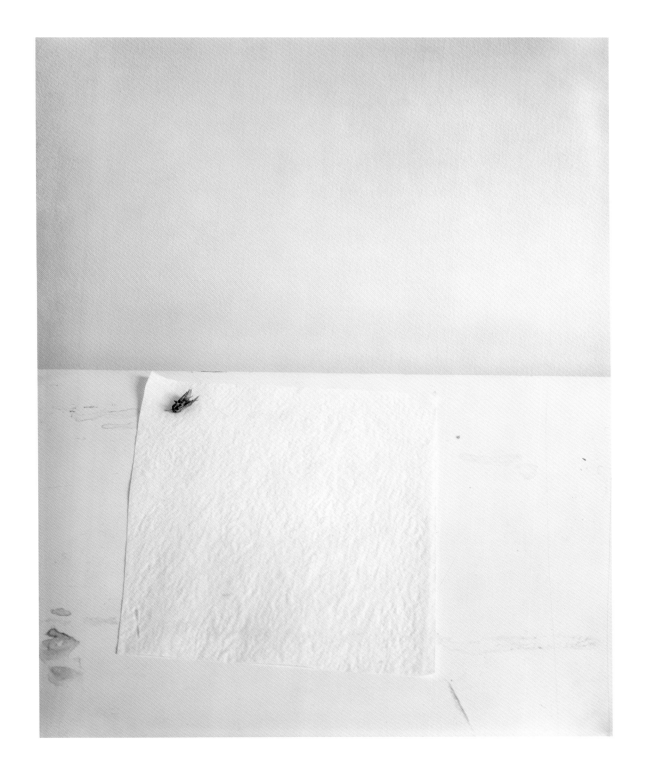

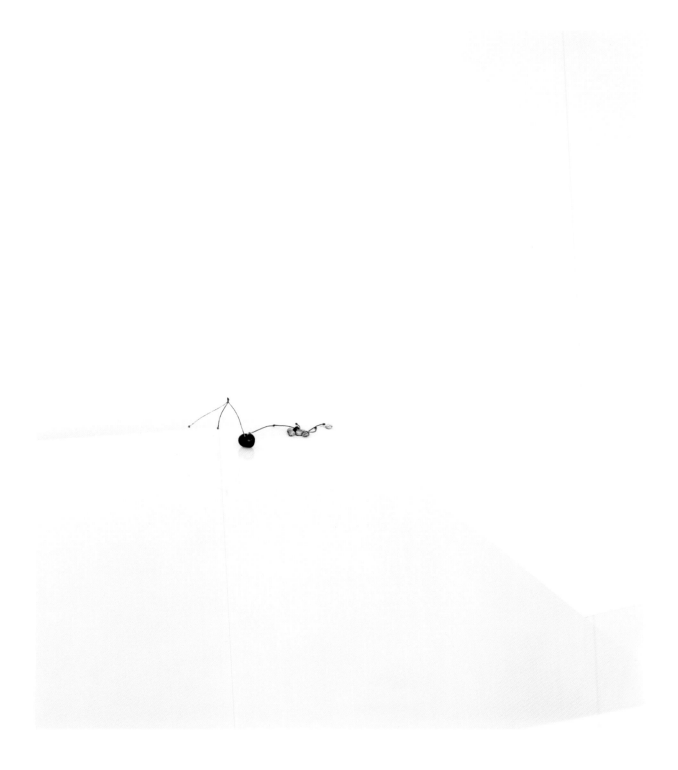

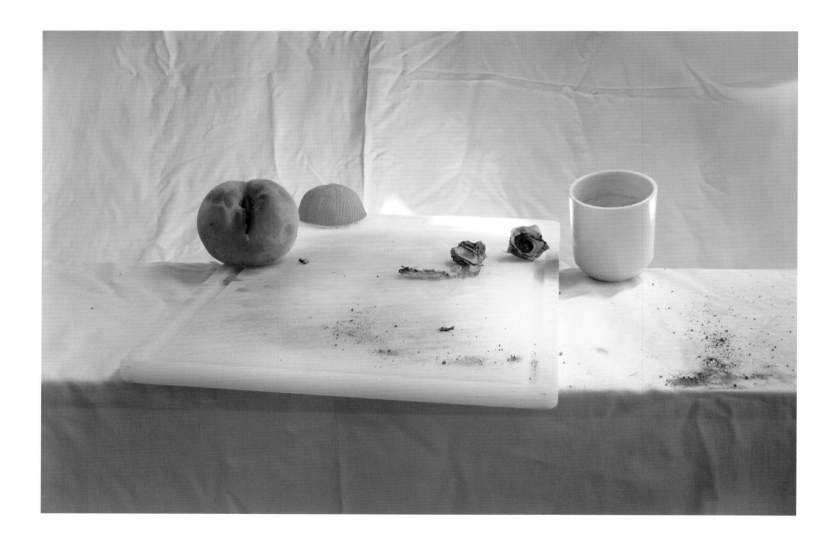

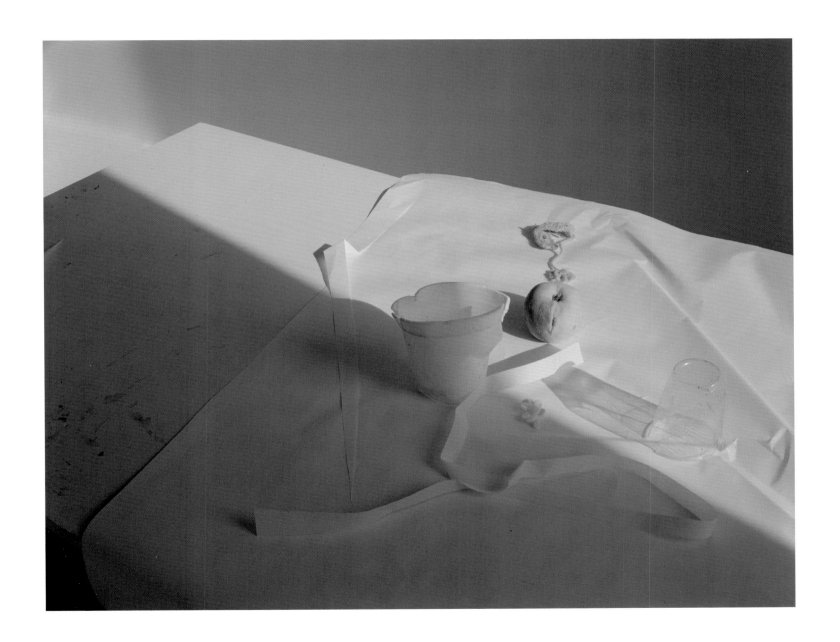

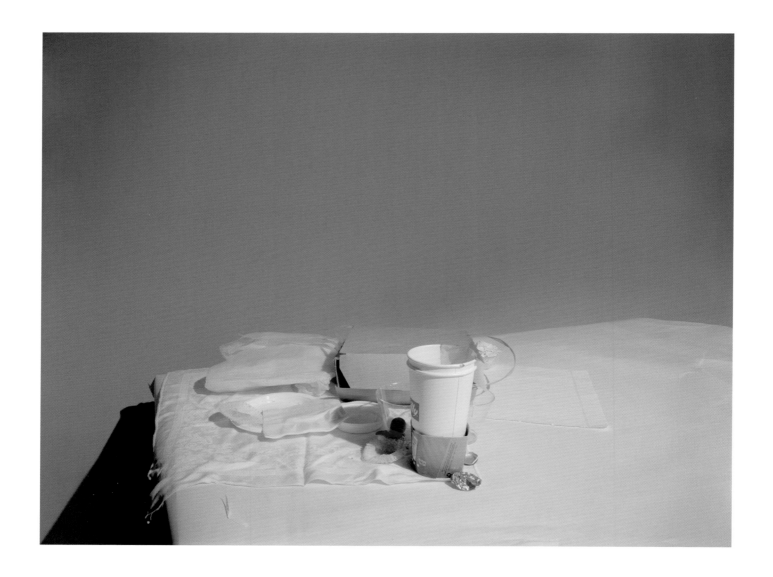

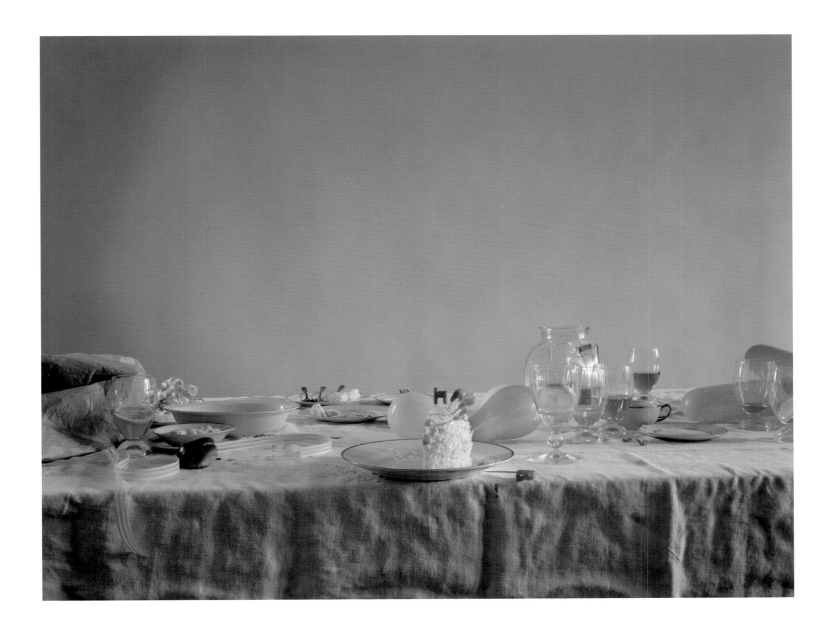

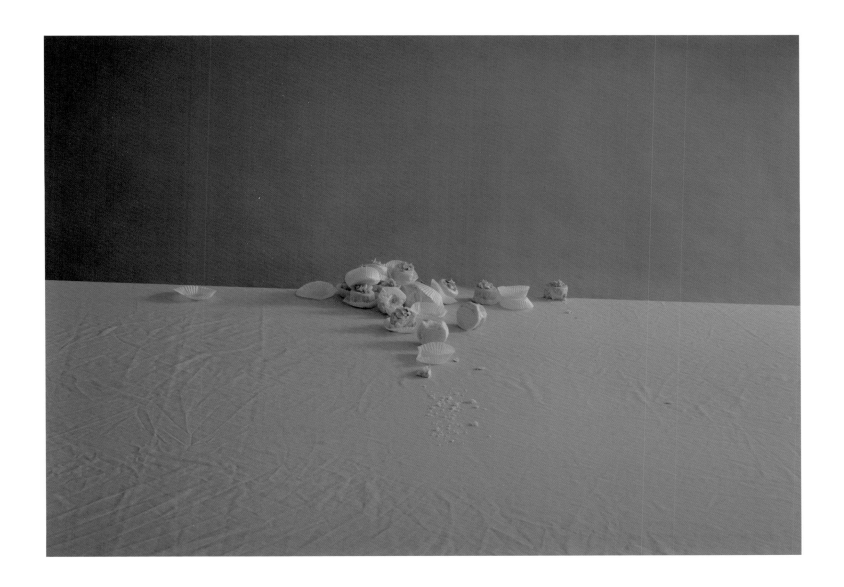

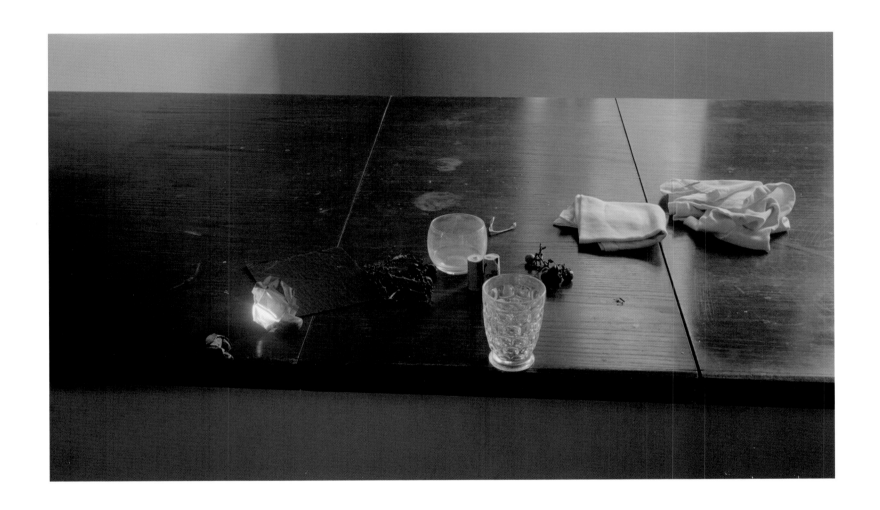

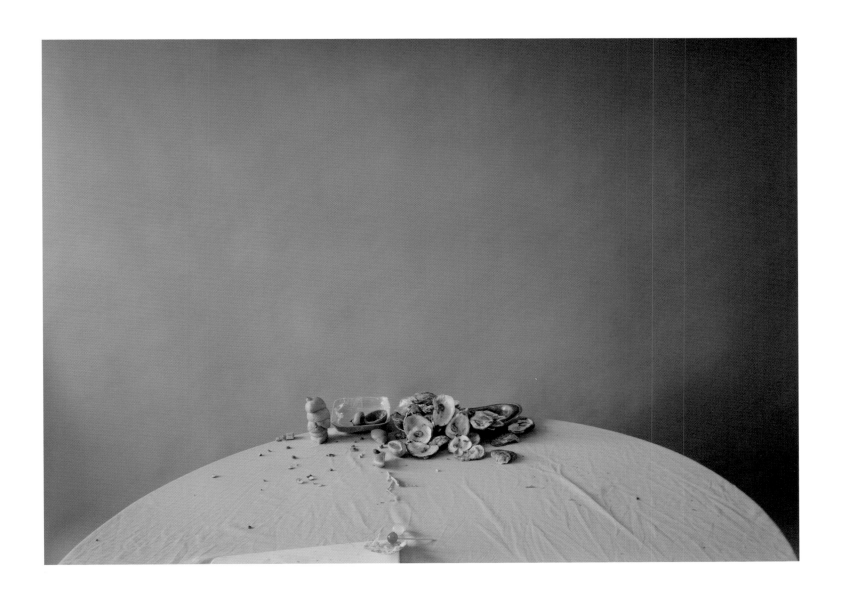

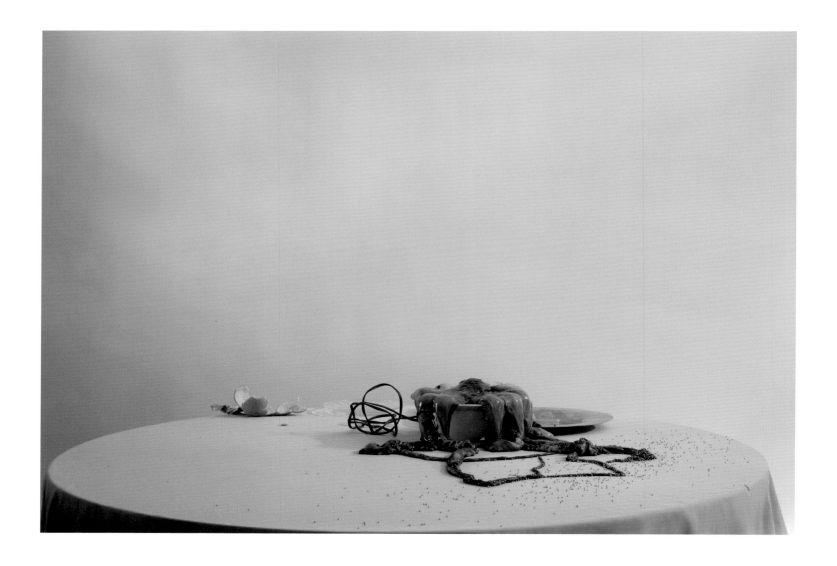

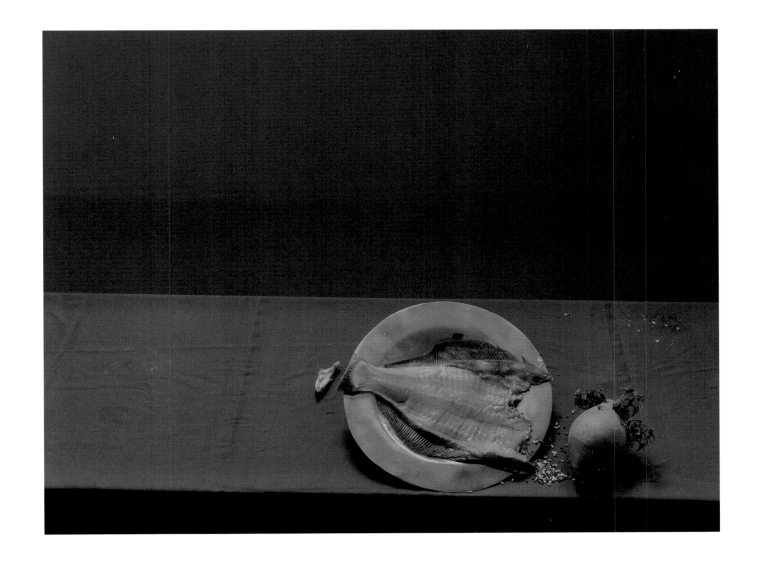

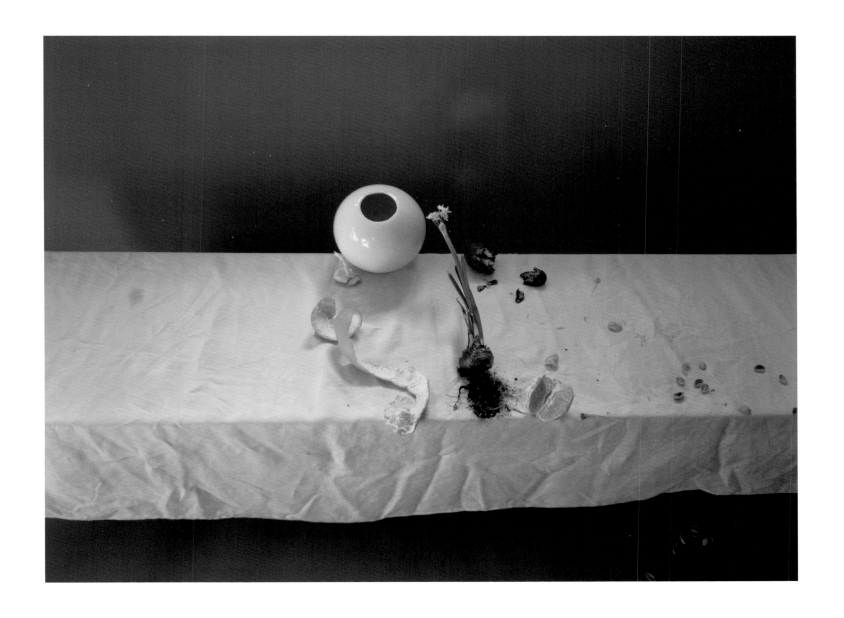

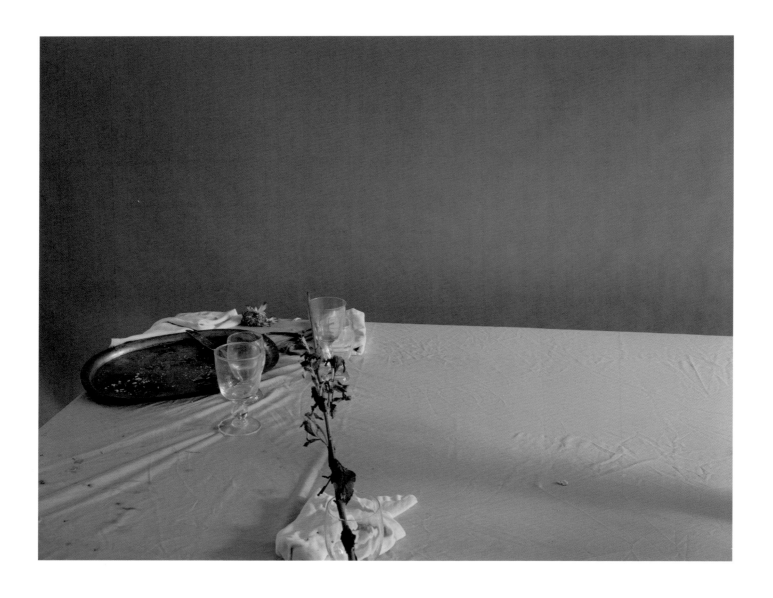

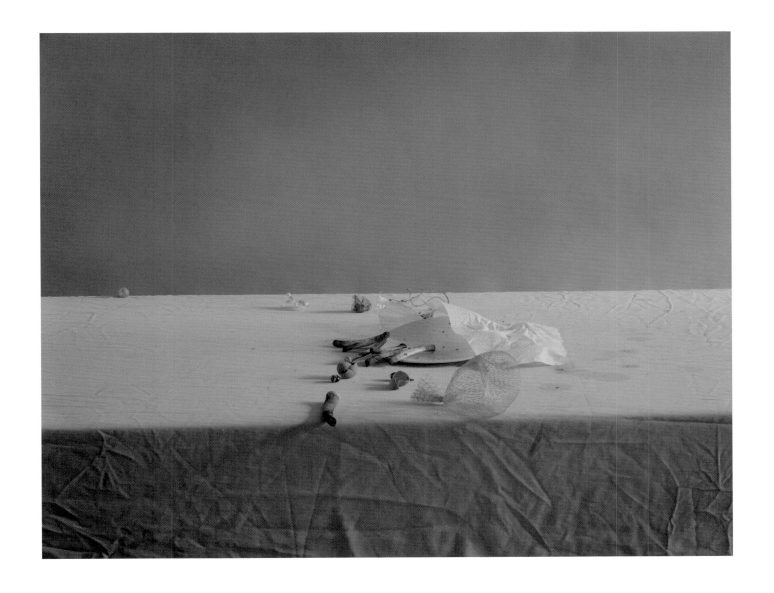

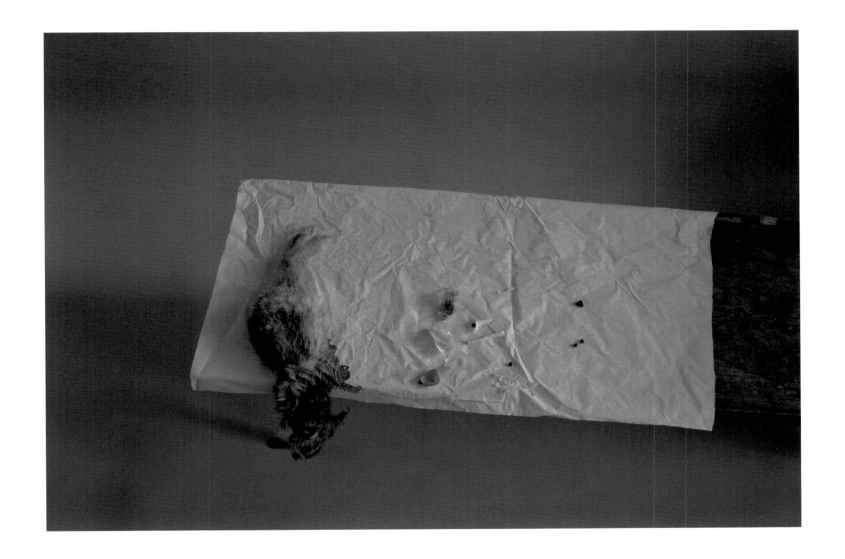

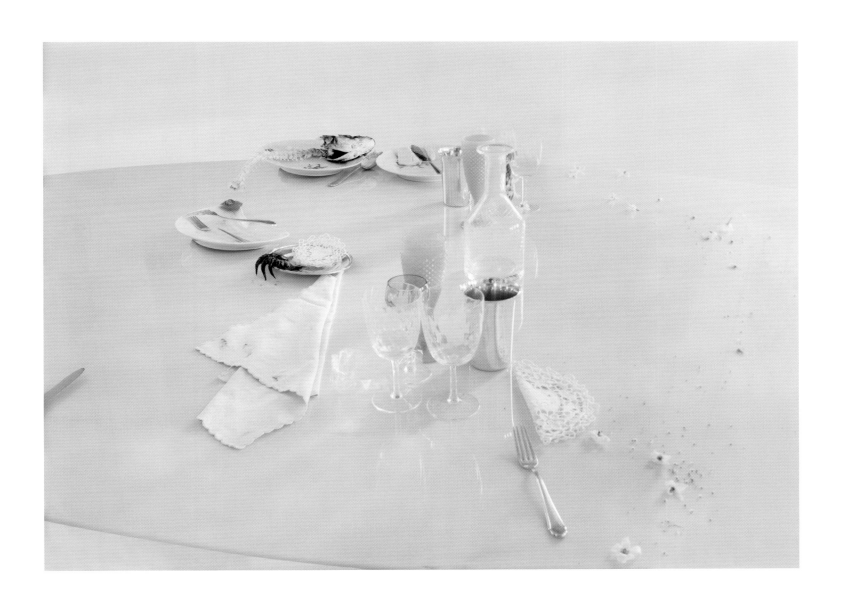

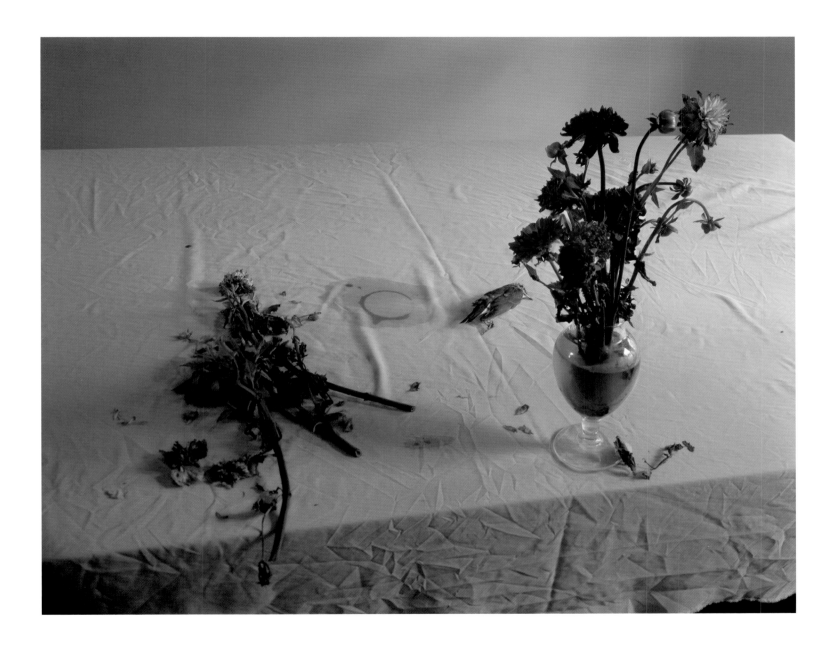

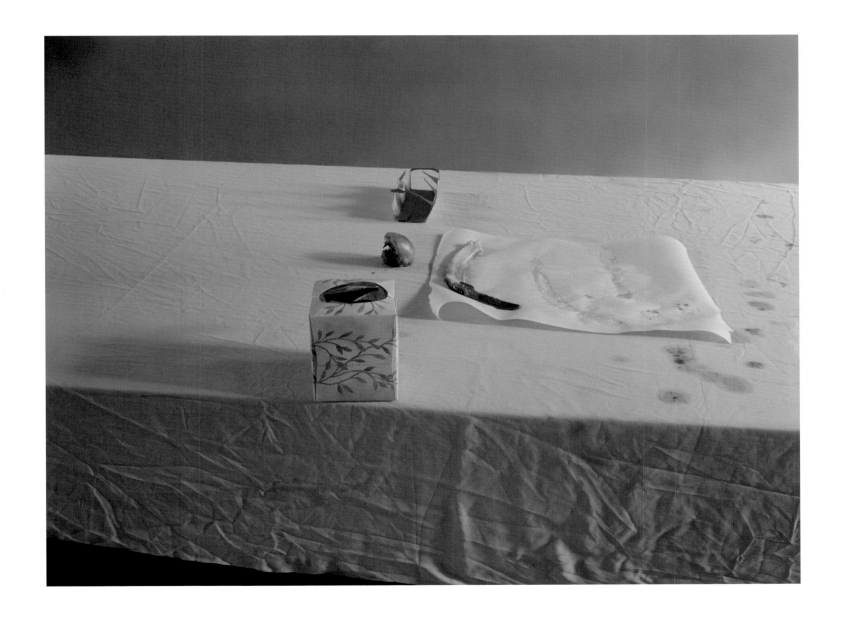

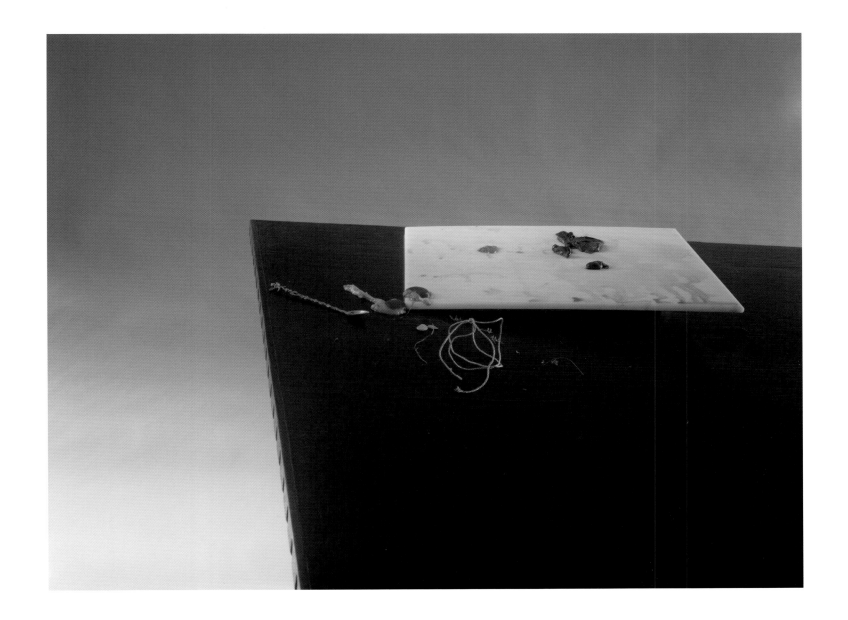

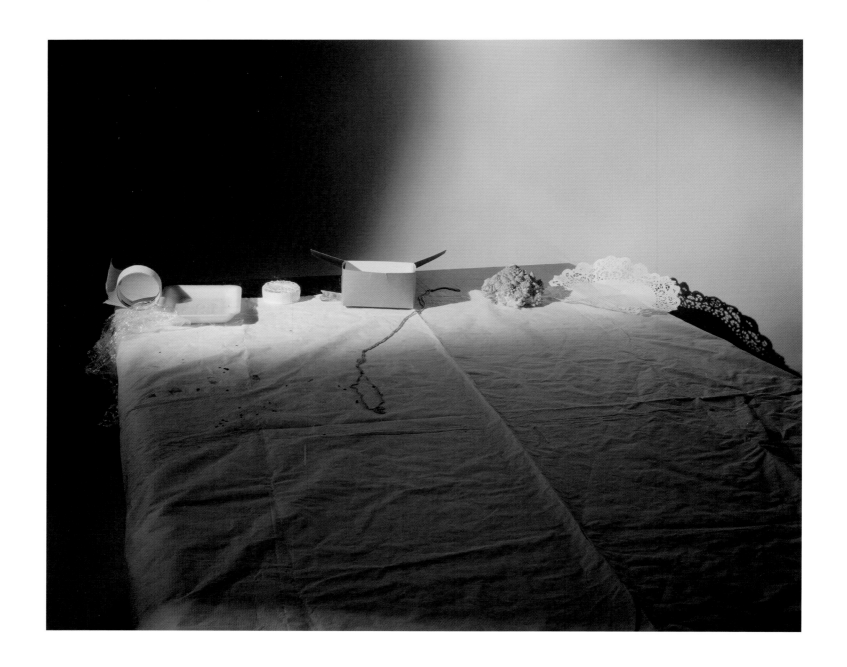

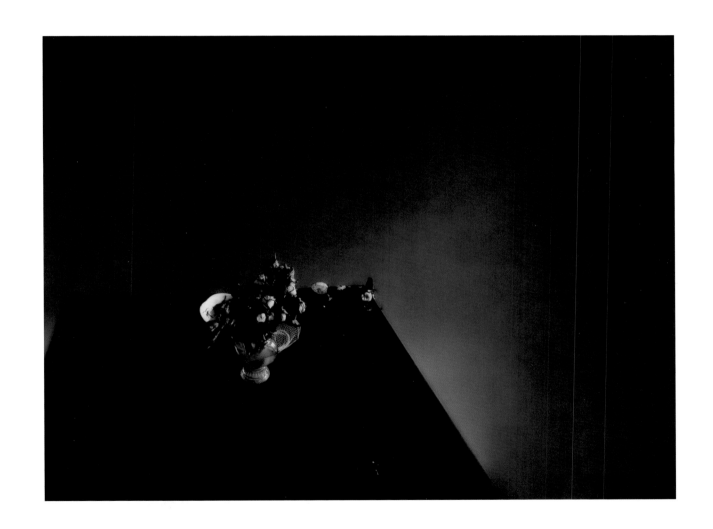

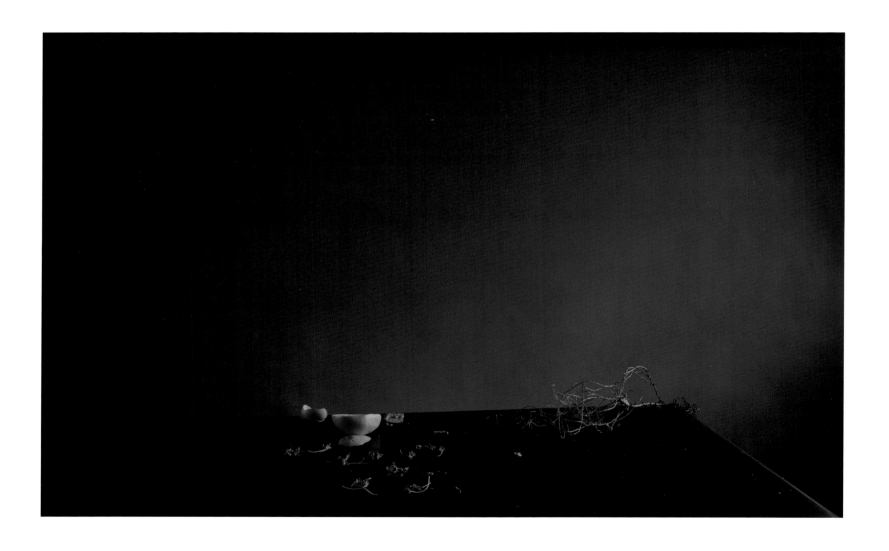

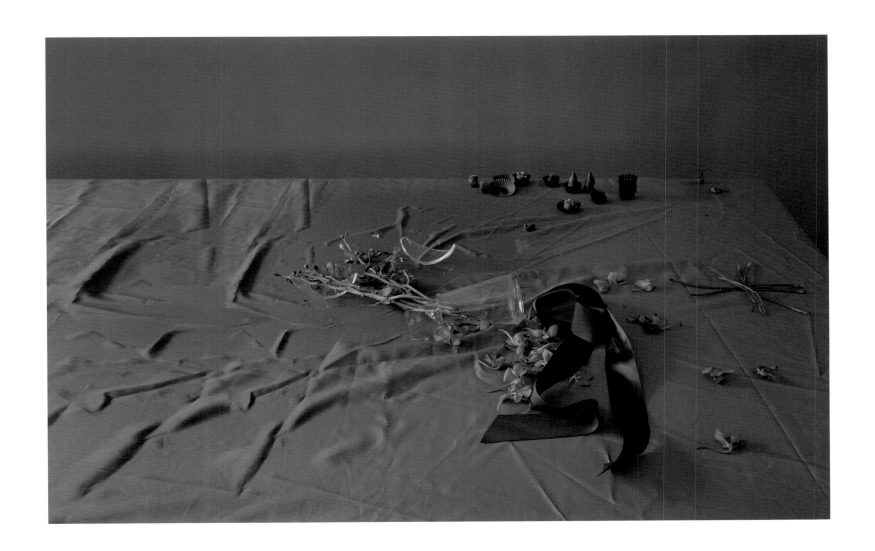

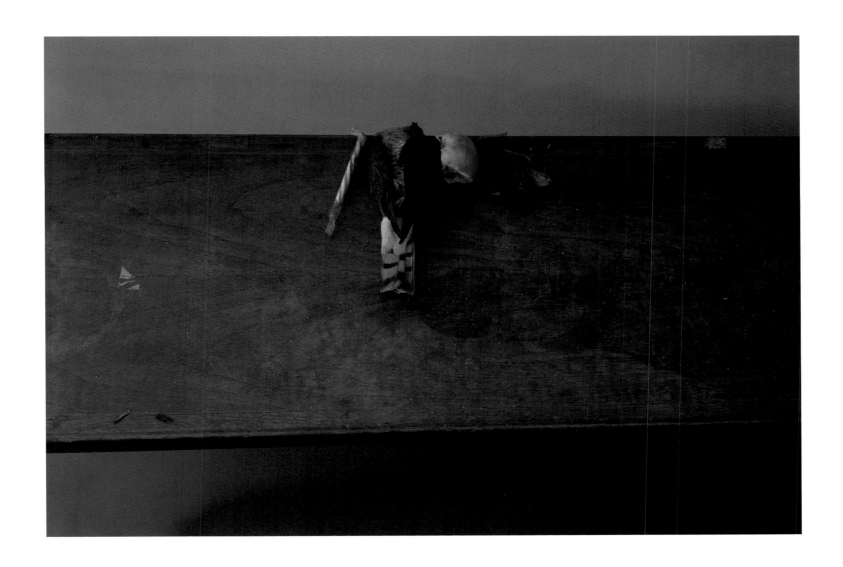

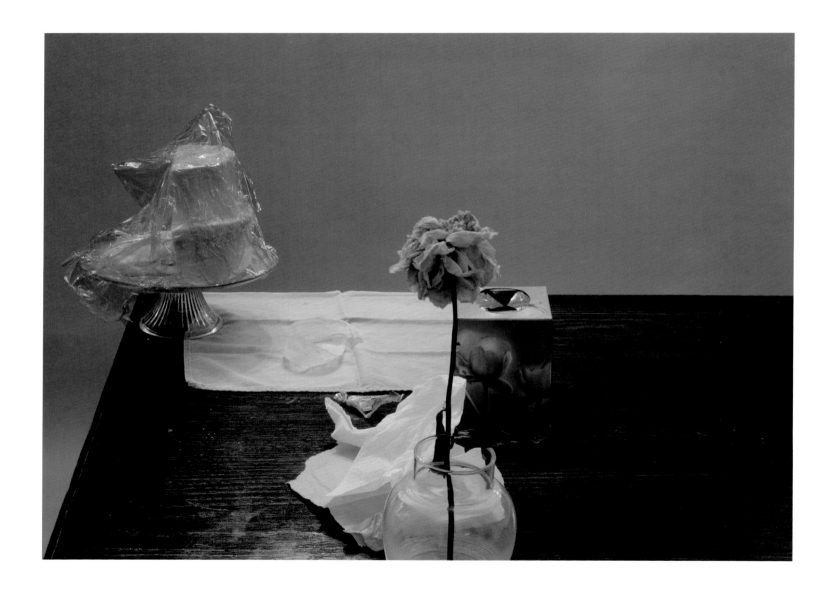

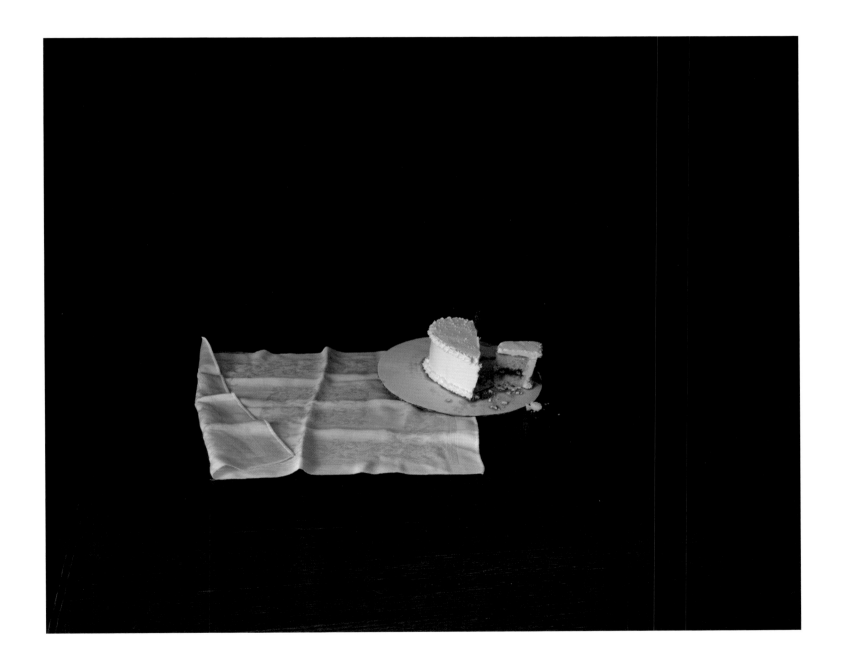

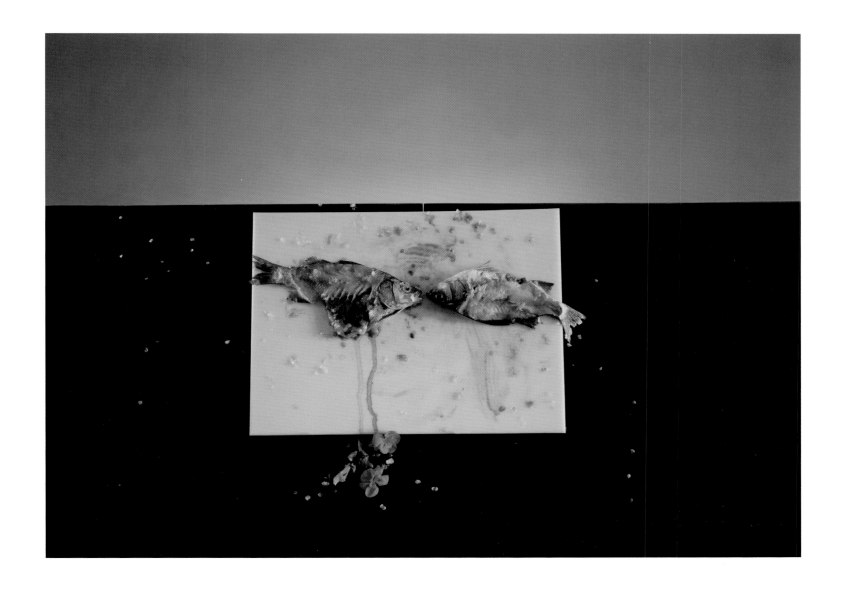

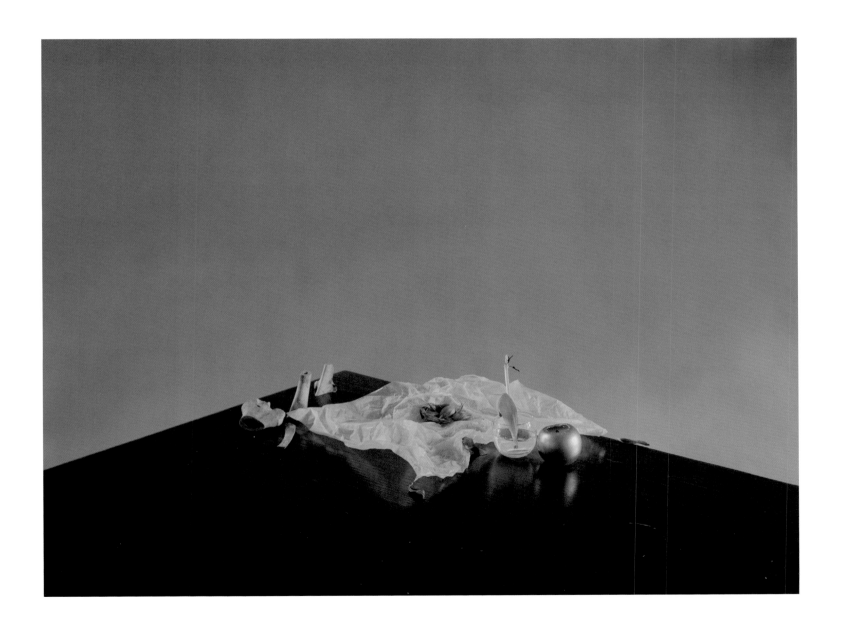

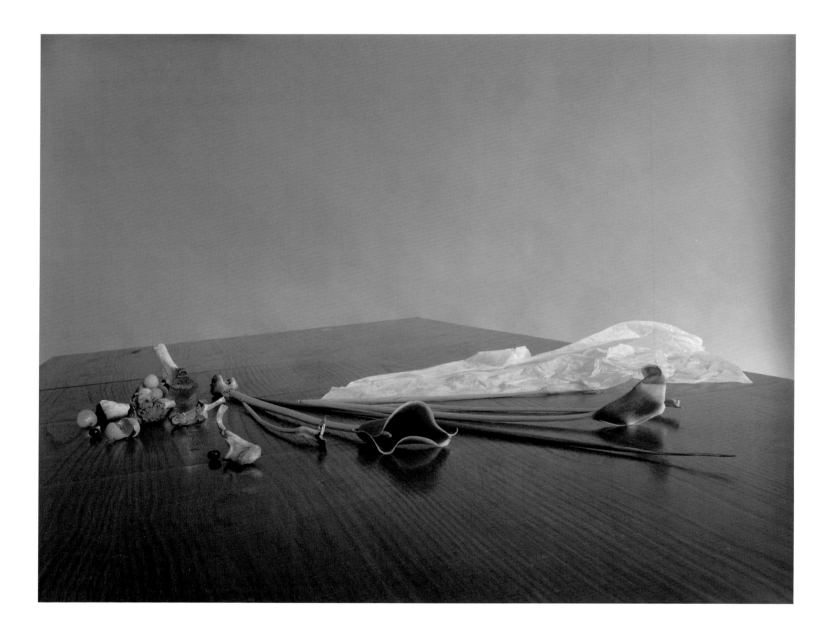

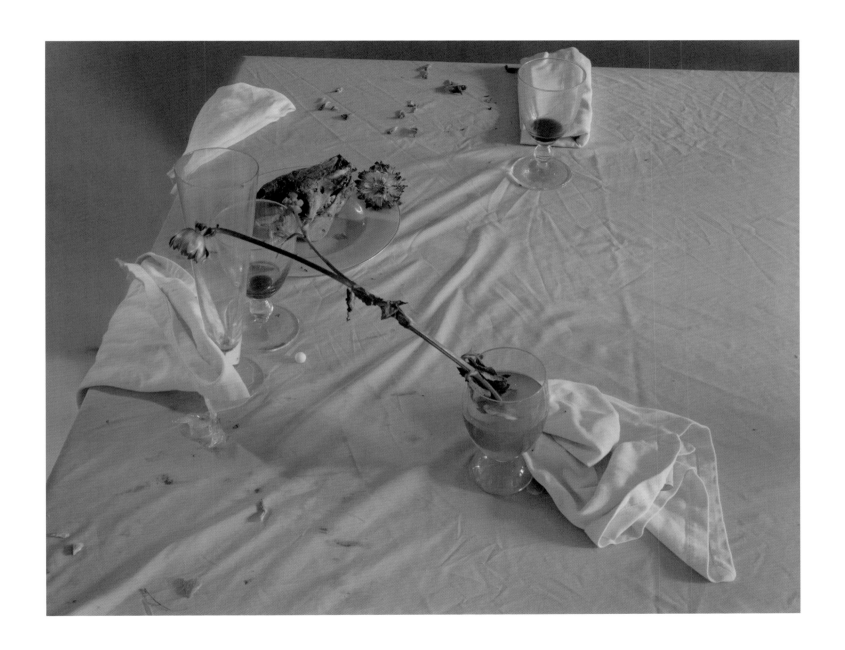

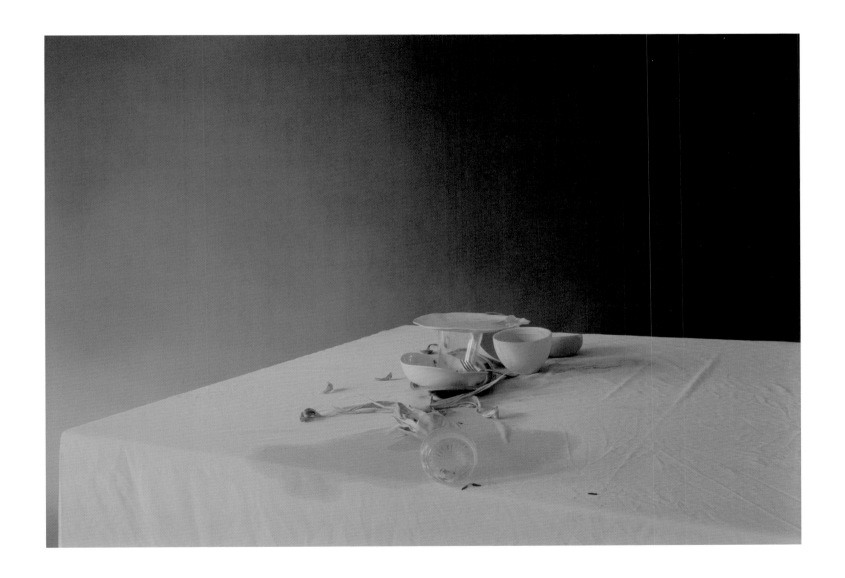

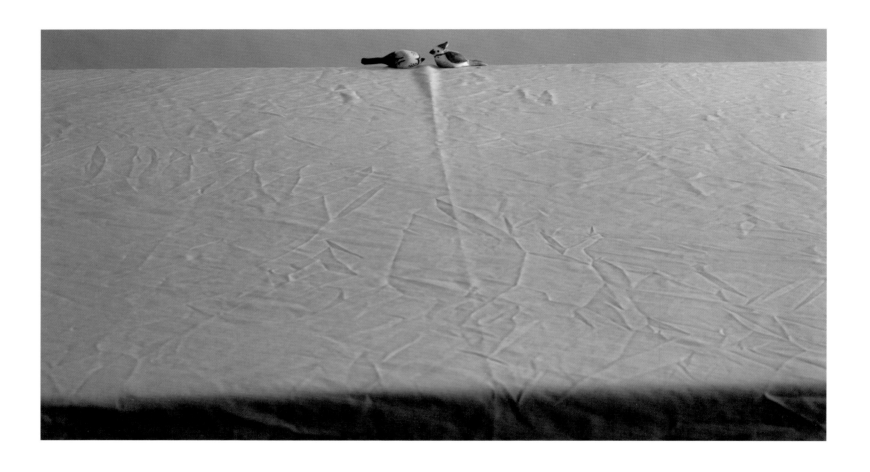

AFTER ALL

51. *Untitled 9*, 2008
The Dog and the Wolf series
40" x 26"

53. *Untitled 19*, 2009
The Dog and the Wolf series
50" x 36"

54. *Untitled 28*, 2009
The Dog and the Wolf series
45" x 31"

55. *Untitled 25*, 2009
The Dog and the Wolf series
40" x 30.83"

57. *Untitled 23*, 2009
The Dog and the Wolf series
45" x 33.8"

58. *Untitled 5*, 2008
The Dog and the Wolf series
45" x 35.23"

59. *Untitled 11*, 2008
The Dog and the Wolf series
50" x 39.3"

61. *Untitled 27*, 2009
The Dog and the Wolf series
45" x 38.8"

63. *Untitled 2*, 2009
Italy series
45" x 32.538"

65. *Untitled 2*, 2008
The Dog and the Wolf series
40" x 31.7"

67. *Untitled 16*, 2009
The Dog and the Wolf series
38" x 28.6"

69. *Untitled 7*, 2008
The Dog and the Wolf series
45" x 35.2"

70. *Untitled 14*, 2008
To Say It Isn't So series
40.513" x 50"

71. *Untitled 14*, 2008
The Dog and the Wolf series
26" X 34"

72. *Untitled 15*, 2009
The Dog and the Wolf series
45" x 28.2"

73. *Untitled 17*, 2009
The Dog and the Wolf series
40" x 25.7"

75. *Untitled 24*, 2009
The Dog and the Wolf series
40" x 27.4"

76. *Untitled 7*, 2006
To Say It Isn't So series
21.813" x 30 "

79. *Untitled 8*, 2006
To Say It Isn't So series
36.45" x 45"

81. *Untitled 10*, 2008
The Dog and the Wolf series
37" x 51"

83. *Untitled 13*, 2008
The Dog and the Wolf series
40" x 30.48"

84. *Untitled 12*, 2008
The Dog and the Wolf series
40" x 31.2"

85. *Untitled 4*, 2008
The Dog and the Wolf series
40" x 31.4"

87. *Untitled 26*, 2009
The Dog and the Wolf series
48" x 33.6"

88. *Untitled 30*, 2009
The Dog and the Wolf series
40" x 21.7"

LAURA L. LETINSKY

CURRICULA VITAE

EDUCATION

1991 Yale University School of Art, New Haven, CT, M.F.A. Photography
1986 University of Manitoba, Winnipeg, MB, B.F.A., Photography

EXHIBITIONS • Selected Solo & Two Person

2010 *The Dog and The Wolf*, Monique Meloche Gallery, Chicago, IL
After All, Yancey Richardson Gallery, New York
Donald Young Gallery, Chicago, IL
2009 *To Want for Nothing,* Brancolini Grimaldi Arte Contemporanea, Rome, Italy
Likeness, James Hyman Gallery, London, England
2008 *Before the colors deepened and grew small,* galerie m Bochum,
Bochum, Germany
2007 *Dirty Pretty Things,* Brancolini Grimaldi Arte Contemporanea, Rome, Italy
To Say It Isn't So, Yancey Richardson Gallery, NY
Somewhere, Somewhere, Stephen Bulger Gallery, Toronto, ONT
2006 *Hardly More Than Ever,* Michael Sturm Gallery, Stuttgart
Somewhere, Somewhere, James Harris Gallery, Seattle, WA
2005 *Hardly More Than Ever,* Galerie Kusseneers, Antwerp, Belgium
Somewhere, Somewhere, Monique Meloche Gallery, Chicago, IL
2004 *Hardly More Than Ever,* The Renaissance Society, Chicago, IL
Hardly More Than Ever, Stephen Bulger, Toronto, ONT
Hardly More Than Ever, Monique Meloche Gallery
Aftermath: Still-life photographs by Laura Letinsky,
Cleveland Museum of Art, OH
2003 *I did not remember I had forgotten,* Edwynn Houk Gallery, New York, NY
2002 *Morning, and Melancholia,* Edwynn Houk Gallery, NY
Venus Inferred-Self Portraits, Stephen Bulger Gallery, Toronto
2000 *Morning, and Melancholia,* Carol Ehlers Gallery, Chicago, IL
1998 *Venus Inferred,* Canadian Museum of Contemporary Photography (touring),
Ottawa, ONT
1997 *Coupling,* Museum of Contemporary Photography, Chicago, IL
1994 *Intimate Stages,* Presentation House, Vancouver, BC

EXHIBITIONS • Selected Group

2010 *Masterworks of American Photography: Moments in Time,*
Amon Carter Museum, TX
2009 *Presence Through Absence,* The Art Gallery of Brampton, ONT

2008 *Interiority,* Hales Gallery, London
Ahh Decadence, Sullivan Galleries, School of the Art Institute Gallery,
Chicago, IL
Made in Chicago; LaSalle Bank Collection, Chicago Cultural Center, Chicago, IL
2007 *RoomXRoom,* James Harris Gallery, Seattle, WA
Allusive Moments, Rena Bransten Gallery, San Francisco, CA
2006 *Time's Arrow ^ Twelve Random Thoughts on Beauty,* Rotunda Gallery, Brooklyn
2005 *Crossings: 5 Artist Cultural Exchange,*
Chicago Cultural Center & Museum of Fine Art
Kaohsiung, Taiwan
2004 *DOMICILE,* Center for Contemporary Art, Seattle, WA
Dust to Dust, University of Essex, England
2002 *Home Stories,* Winnipeg Art Gallery (International Touring Exhibition)
2001 *Subjects/Objects,* Art Institute of Chicago, Chicago, IL
The Power of Reflection, Saidye Bronfman Center, Montréal, QUÉ
2000 *L'image complice,* Nederlands Foto Instituut, Rotterdam, Brussels, Casino,
Chicago (Touring)
Crossing the Line, Art Institute of Chicago, Chicago, IL
1999 *Domesticated,* Worcester Museum, Worcester, MA
1995 *Versimilitudes and the Utility of Doubt,* White Columns Gallery, New York, NY
The Body Photographic, The Contemporary Arts Center, New Orleans, LA
1994 *New Acquisitions,* San Francisco Museum of Modern Art, CA
1991 *The Pleasures and Terrors of Domestic Comfort,* Museum of Modern Art,
NY, NY; touring

AWARDS AND HONORS

2003 Richard Driehaus Award, Chicago, IL
2002 Illinois Arts Council Grant
2001 Anonymous Was A Woman, New York, NY
2000 John Simon Guggenheim Fellowship Award – Photography
1998 Canada Council Grant for Visual Artists; also 1994, and 1992
1993 The Barbara Spohr Endowment Award, Banff Center for the Arts
1988-7 Manitoba Arts Council Visual Arts Grants

COLLECTIONS

Amon Carter Museum, TX
Art Institute of Chicago, Chicago, Il
The J. Paul Getty Museum, Los Angeles, CA
Jersey City Museum, NJ
LaSalle Bank Photography Collection, Chicago, IL
Musee des Beaux-Arts, Montreal, QUE
Museum of Contemporary Art, Chicago, IL
Museum of Contemporary Photography, Chicago, IL
Museum of Fine Arts, Houston, TX
San Francisco Museum of Art, CA
Winnipeg Art Gallery, MB
Yale University Art Gallery, New Haven, CT

TEACHING

1994-present, Professor, University of Chicago, IL

REVIEWS AND ARTICLES• Selected

2008 Sleek Magazine, Germany
Elle Décor, May, Vicky Lowry
Photonews: Zeitung für Fotografie, N. 9/10, September
2008 Art on Paper, November/December
2006 *Border Crossings*, Winnipeg, Canada
2004 *House and Garden*, April/May, w. interview Carol Cunningham
New York Times, Review by Grace Gluck
ArtForum, January, Preview by Stephen Frailey, "50 Top Previews,"
Contemporary Magazine, interview with Charlotte Cotton
2003 *Frieze*, October, Review by Polly Ulrich
2002 *The New York Times*, Friday, March 8, Review by Grace Glueck
2001 *New York Times*, Arts and Entertainment,
Review by Vicky Goldberg, August 5
2000 *Art in America*, Review by Susan Snodgrass, December
1999 *Art On Paper*, Vol. 3 No. 3
1998 *Artforum,* June, Review by Nico Israel
The New York Times, Friday, January 23, Review by Grace Gluek
1997 *The Art Newspaper*, November, Interview w. Max McKinna
1989 "The World Going on Without Us", Border Crossings,
January 1989, V8 #1

PUBLICATIONS AND CATALOGS • Selected

2009 Farenheit Magazine, Mexico City, Mexico
2006 *Stilled*, Iris Publications, Stoke-on-Trent, UK
2005 *Now Again*, Galerie Kusseneers, Antwerp, Belgium
Art and Photography, Susan Bright, editor, Thames and Hudson, London
Invented Melodrama in Contemporary Photography,
UIMA and The Neuberger Museum of Art
2004 *Hardly More Than Ever*, The Renaissance Society, Chicago, IL
Criticizing Photographs: An Introduction to Understanding Images, Terry Barrett,
McGraw-Hill, NY
Chicago Photographs: From the LaSalle Bank Photography Collection, LaSalle
Bank, Chicago, IL
2003 *Eating Architecture,* MIT Press, NY
"Feminine Persuasions", Catalogue, Kinsey Institute, Bloomington, Indiana
2002 *Blink*: 100 Contemporary Photographers, Phaidon Press, London, England
2000 *Venus Inferred* (w. Essay by Lauren Berlant), University of Chicago Press, Chicago, IL
Intimacy, University of Chicago Press, Chicago, IL
1999 *Voyeur*, Steve Diamond, editor, Harpercollins, New York, NY
1997 *Surface: Contemporary Photographic Practice*, Booth Clibborn Publishers, England
1996 *Exploring Color Photography*, 3rd Edition, Robert Hirsch, McGraw-Hill, New York, NY

LAURA L. LETINSKY

ACKNOWLEDGEMENTS

In making these pictures I tried to work from and in a place other than visual. The process has felt more like finding my way in the dark by following my nose, ears, skin, and heart (or was the spleen?). The experience has filled these pictures with particular sensory intensity, despite their indisputable presence as pictures.

To Yancey Richardson and her wonderful staff, especially Tracey Norman and David Carmona: thank you for your support and for making this part of the art world so warm. Yancey's discerning eye, fantastic taste, and good sense helped immensely as I struggled to sort through these last few years of work. Alice Rose George's equally striking sensibility was integral to shaping the book and indeed, to its very life. I have admired Alice's keen photographic sense over the decades since I first met her so it has been a delight to experience firsthand her belief in and commitment to artists and their work. And it is a special honor to have my pictures in proximity to Mark Strand's words. Fiction and poetry offer important road maps for me and his poetry has long been an especially powerful source of inspiration.

Thanks are also due to many additional colleagues. I am happily beholden to my other gallerists — Isabella Brancolini, Susanne Breidenbach, Stephen Bulger, Valery Carberry, Camilla Grimaldi, James Hyman, Monique Meloche, Christiane Monarchi, Donald Young, and Michael Sturm — for their ongoing backing, understanding, and enthusiasm. I am grateful to all those who have supported my work over the years including writers, collectors, and curators. Special thanks go to Susanne Ghez, director of the Renaissance Society, who gives artists the best imaginable exhibition experience by sharing her wisdom, exquisite insight, helpful critique, and friendship. The University of Chicago where I am fortunate to be a professor provides a provocative and rigorous environment, invaluable students and peers, and consistent support. The professionalism and perfectionism of my printers at Blackpoint Editions, Nate Baker and Aron Gent, has made the process of creating the prints a delight. Lastly, and vitally, to Jason Pickleman whose incredibly sensitive and beautiful design makes this book glow.

To my friends, especially Jessica Morgan and John Mark Horton, thank you for your not always gentle but always loving words and presence that keeps me thinking and making. To my grad school friends Marion Belanger, Mary Berridge, Ann Daly, Tanya Marcuse, and Jeanette Williams, I am forever grateful for bi-yearly lunches when we actually get to break bread as well as our innumerable, enduring, and most welcome phone conversations. For saying just the thing I need even if I don't want to hear it, thanks to Karen Reimer who has tried to keep me from slipping too far into melodrama while nurturing a shared streak of comic melancholy. Thanks too to Stephanie Smith, for being a wonderful colleague and amazing, wise, optimistic, and generally fabulous friend , and to David Schutter, for his similarly inclined sensibility, acerbic humor, and deep intelligence. For their love, in all its glory and its messiness, thank you to my family, Tony, Clyde, and Louis. Finally, and mostly, thank you to my mom, Ada, for her strength, smarts, and love.

En prenant ces photographies, j'ai essayé de travailler à partir d'un lieu et dans un lieu autre que visuel.

Le processus a été plus celui de trouver mon chemin dans le noir en suivant mon nez, mes oreilles, ma peau et mon cœur (ou étaient-ce les tripes?). Cette expérience a rempli mes photos d'une intensité sensorielle particulière, malgré leur indiscutable présence en tant que photos.

Merci à Yancey Richardson et à sa formidable équipe, en particulier Tracey Norman et David Carmona, de leur soutien et de rendre si chaleureuse cette partie du monde de l'art. Le regard perçant de Yancey, son goût fantastique et son bon sens m'ont immensément aidée quand je luttais pour faire le tri parmi les dernières années de travail. L'étonnante sensibilité d'Alice Rose George a été indispensable pour donner forme et vie au livre. J'admire le vif sens photographique d'Alice depuis des décen-

nies, depuis notre première rencontre, et ça a été un plaisir de vivre à la première personne sa foi dans les artistes et son engagement pour leur travail. Et c'est un honneur particulier de voir mes photos à côté des mots de Mark Strand. La fiction et la poésie sont pour moi des cartes routières et sa poésie a longtemps été une source d'inspiration particulièrement puissante.

Mes remerciements vont aussi à de nombreux autres collègues. Je suis redevable à mes autres galeristes - Isabella Brancolini, Susanne Breidenbach, Stephen Bulger Camilla Grimaldi, James Hyman, Monique Meloche, Christiane Monarchi, Donald Young, et Michael Sturm - pour leur soutien, leur compréhension et leur enthousiasme. Je suis reconnaissante envers tous ceux qui ont soutenu mon travail au cours des années, y compris les écrivains, collectionneurs et conservateurs. Tous mes remerciements à Susanne Ghez,

directrice de la Renaissance Society, qui donne aux artistes la meilleure expérience d'exposition possible en partageant sa sagesse, son exquise perspicacité, sa critique constructive et son amitié. L'Université de Chicago, où j'ai la chance d'être professeur, fournit un environnement provocant et rigoureux, des étudiants et des pairs inestimables, et un soutien consistant. Le professionnalisme et le perfectionnisme de mes imprimeurs à Blackpoint Editions, Nate Baker et Aron Gent, a transformé le processus de création de ces impressions en un moment de plaisir. Enfin, un grand merci à Jason Pickleman dont la conception incroyablement sensible et belle a donné de l'éclat à ce livre.

À mes amis, en particulier Jessica Morgan et John Mark Horton, merci pour vos paroles qui ne sont pas toujours douces, mais sont toujours aimantes, et pour votre présence qui m'aide à penser et à faire. À

mes amies de l'université Marion Belanger, Mary Berridge, Ann Daly, Tanya Marcuse, et Jeanette Williams, je vous suis éternellement reconnaissante pour nos déjeuners bi-annuels et pour nos conversations téléphoniques innombrables, longues et toujours bienvenues. Merci à Karen Reimer de me dire ce dont j'ai besoin même si je n'ai pas envie de l'entendre et d'avoir essayé de m'empêcher d'aller trop loin dans le mélodrame tout en nourrissant des traces partagées de mélancolie comique. Merci à Stephanie Smith d'être une collègue formidable et une amie étonnante, sage, optimiste et de manière générale fabuleuse, et à David Schutter pour sa sensibilité proche de la mienne, son humour acerbe et son intelligence profonde. Merci à ma famille, Tony, Clyde et Louis, pour leur amour, dans toute sa gloire et son désordre. Enfin et surtout, merci à ma mère, Ada, pour sa force, son bon sens et son amour.

Mentre scattavo queste fotografie ho tentato di muovermi in uno spazio che non fosse visivo, come avanzare a tentoni nel buio affidandomi al naso, alle orecchie, alla pelle, al cuore (o era la milza?). Perciò queste immagini sono cariche di una particolare intensità sensoriale, nonostante la loro indiscutibile presenza in quanto oggetti visivi.

A Yancey Richardson e al suo meraviglioso staff, in particolare a Tracey Norman e David Carmona: grazie per il vostro sostegno e per aver reso così calorosa questa parte del mondo dell'arte. L'occhio critico di Yancey, il suo gusto superlativo e il suo buon senso mi hanno aiutata enormemente mentre mi affannavo a mettere ordine in questi ultimi anni di lavoro. La sensibilità straordinaria di Alice Rose George è stata vitale per la struttura e l'esistenza stessa di questo libro. Sin dal nostro primo incontro, e nel corso dei decenni, ho ammirato il suo acutissimo senso fotografico, ed è stato un piacere sperimentare in prima persona la sua fiducia e il suo impegno verso gli artisti e il loro lavoro. Ed è un onore particolare vedere le mie fotografie pubblicate accanto alle parole di Mark Strand. Narrativa e poesia sono come carte stradali per me, e le sue poesie sono da tempo una fonte d'ispirazione particolarmente potente.

Devo ringraziare anche molti altri colleghi. Sono grata ai miei altri galleristi – Isabella Brancolini, Susanne Breidenbach, Stephen Bulger Camilla Grimaldi, James Hyman, Monique Meloche, Christiane Monarchi, Donald Young e Michael Sturm – per il continuo sostegno, la comprensione e l'entusiasmo. Sono riconoscente a tutti quelli che hanno sostenuto il mio lavoro nel corso degli anni, compresi gli scrittori, i collezionisti e i curatori. Un ringraziamento particolare va a Susanne Ghez, direttrice del-

la Renaissance Society, che offre agli artisti un'impareggiabile esperienza espositiva, condividendo con loro un'enorme saggezza, un intuito raffinato, un utile spirito critico e la sua amicizia. La University of Chicago dove ho la fortuna di insegnare mi offre un ambiente stimolante e rigoroso, studenti e amici impagabili e un sostegno costante. La professionalità e il perfezionismo dei miei stampatori della Blackpoint Editions, Nate Baker e Aron Gent, ha reso il processo di stampa un vero piacere. Infine, vitale, Jason Pickleman, che con l'incredibile sensibilità della grafica è riuscito a far splendere questo libro.

Ai miei amici, in particolare a Jessica Morgan e a John Mark Horton, grazie per le parole e la presenza, non sempre delicate ma sempre amorevoli, che mi hanno saputo mantenere viva nel pensare e nel fare. Alle mie amiche di master – Marion Belanger, Mary Berridge, Ann Daly, Tanya Marcuse e Jeanette Williams – eterna gratitudine per i pranzi semestrali in cui riusciamo finalmente a spezzare il pane insieme, ma anche per le nostre sacre e innumerevoli conversazioni telefoniche. Per aver detto esattamente la cosa di cui avevo bisogno anche quando non volevo sentirmela dire, ringrazio Karen Reimer che ha cercato di impedirmi di scivolare troppo nel melodramma, alimentando la nostra vena comune di malinconia comica. Grazie a Stephanie Smith, per essere una meravigliosa collega oltre che un'amica stupenda, saggia, ottimista e favolosa in tutto, e a David Schutter, per la sua analoga sensibilità, l'umorismo tagliente e la profonda intelligenza. Per l'amore che mi ha dato, fra gloria e caos, ringrazio la mia famiglia: Tony, Clyde e Louis. Infine, e soprattutto, ringrazio mia madre, Ada, per la forza, l'intelligenza e l'amore.